Wisconsin Barn Quilt
Coloring Book Two

John H. Lettau

Signs of Spring

Star Bound

The Farmer's Family

Barn Quilts of Shawano County, Wisconsin

Cover Quilts

All Points...Beran's Dairy...Wintery Reflections
Peterson Century Feeders
Gentleman's Fancy...Twisting Star...Star of Empire
Friendship Star...North Star

2016 Copyright John H. Lettau & Shawna Lettau

Shawano County Wisconsin Barn Quilt Project

A drive through Shawano County is very colorful today because more than 300 brillant "quilt blocks," called barn quilts, are on display on barns throughout the county. Five county barn quilts displayed above...Double Square, A Saluting to Dairying, Maple Leaf Star, Garden Square & Phoenix.

The Shawano county barn quilt project was started by Shawano writer/photographer Jim Leuenberger in 2010. In June 2010 Jim proposed the idea to local 4-H clubs as possible club service project. Since then, several clubs have sponsored and painted barn quilts. And individual barn owners, businesses and individuals have supported the project through sponsoring a quilt and/or having quilt put on their barn.

Shawano County Barn Quilt Project Objectives

1. To encourage the preservation of Shawano County's historic barns.
2. To promote tourism for Shawano County
3. To provide an opportunity for groups like 4-H clubs, FFA chapters and others to sponsor and paint a barn quilt as a community service project.

What is a Barn Quilt?

A barn quilt is made by painting a quilt pattern on two 4' by 8' sheets of ¾ " plywood then mounting them on a barn to form an eight foot square. Two coats of primer are applied to both side of the boards plus the edges. After the pattern is drawn out, Frog (painters) tape ls applied. Three coats of each color are applied, with each coat being allowed to dry overnight. After the quilt is finished, it is allowed to dry for at least two weeks before it is put upon the barn.

When someone wanted quilt for their barn, they met with Leuenberger to pick out a pattern and the colors they wanted it painted in. Since January 2011, at least one barn quilt was put up In Shawano County every month for 52 month in a row.

Shawano County Barn Quilt Project Information

Books-Maps-Information-Tours

Shawano County Chamber of Commerce & Visitors Center
1623 South Main Street
Shawano, Wisconsin 54166
715-524-2139 805 235 8528 www.shawanocounty.com

Shawano County Wisconsin Barn Quilts Book Two

Name	Location	Town
Let Freedom Ring	County Trunk CC	Shawano
Maple Leaf Star	Church Rd	Birnamwood
Four Crowns	Hwy 22	Clintonville
Peterson Century Feeder	County Rd C	Clintonville
Phoenix	Old Hwy 47	Pulaski
Just Because	East Freeborn St	Cecil
Star of Empire	Burma Rd	Marion
Grandmother's Own	Meadow Lane	Shawano
Cross	Maple Lane	Tigerton
North Star	State Hwy 22	Shawano
Octagonal Star	South St. Augustine St	Pulaski
Twisting Star	Sate Hwy 153	Wittenberg
Star Bound	Willow Rd	Pulaski
Liberty Banner	Belle Plaine Ave	Shawano
Pinwheel	Beech Drive	Bonduel
Rainbow (Rehn) Paradox	Green Valley Rd	Krakow
Quarterfoils	County Rd M	Shawano
Gentleman's Fancy	County Rd BE	Bonduel
Patriotic Star	Broadway	Shawano
Garden Square	State Hwy 29	Pulaski
Pinwheel Flag	Old Lake Rd	Shawano
Friendship Star	Swamp Rd	Bonduel
Patchwork Pines	Spruce Rd	Shawano
Card Basket	Short Lane	Eland
Double Square	Green Valley Rd	Pulaski
Signs of Spring	Angelica Drive	Krakow
Farmer's Family	Kratzke Rd	Clintonville
Starshadow	State Hwy 156	Shiocton
Wishing Star	County, Rd BE	Bonduel
Autumn's Rainbow	County Rd Z	Birnamwood
Summer Star Flower	Maple Road	Seymour
Prairie Sunrise	Oakcrest Drive	Bonduel
Pumpkin Star	Western Ave	Birnamwood
Beran's Dairy	Field St	Birnamwwood
Norwegian Pride	Hemlock Rd	Wittenberg
Brown Swiz	Shorewood Lane	Clintonville
Ornate Star	Church Rd	Birnamwood
Friendship Star	Farmall Lane	Caroline
Rose Mosaic	Kolpack Rd	Bowler
All Points	Much Rd	Tigerton
Pinwheel Star	Fair-Morr Rd	Tigerton
All American	East Main St	Clintonville
A Salute to Dairying	Cedar Rd	Pulaski
Rueden Maple Leaf	State Hwy 156	Pulaski
Wintery Reflections	Wilson Creek Lane	Wittenberg
Wayne's Dilemma	State Hwy 22	Shawano
Mother's Choice	Tower Rd	Tigerton
Twirling Star	Sugarbush Rd	Birnamwood

Barn Quilt Let Freedom Ring
Shawano County Wisconsin Barn Quilts

Barn Located
County Trunk CC
Shawano, Wisconsin

Wisconsin Barn Quilt Let Freedom Ring

Barn Quilt Maple Leaf Star
Shawano County Wisconsin Barn Quilts

Barn Located
Church Rd
Birnamwood, Wisconsin

Wisconsin Barn Quilt Maple Leaf Star

Barn Quilt Four Crowns
Shawano County Wisconsin Barn Quilts

Barn Located
State Hwy 22
Clintonville, Wisconsin

Wisconsin Barn Quilt Four Corners

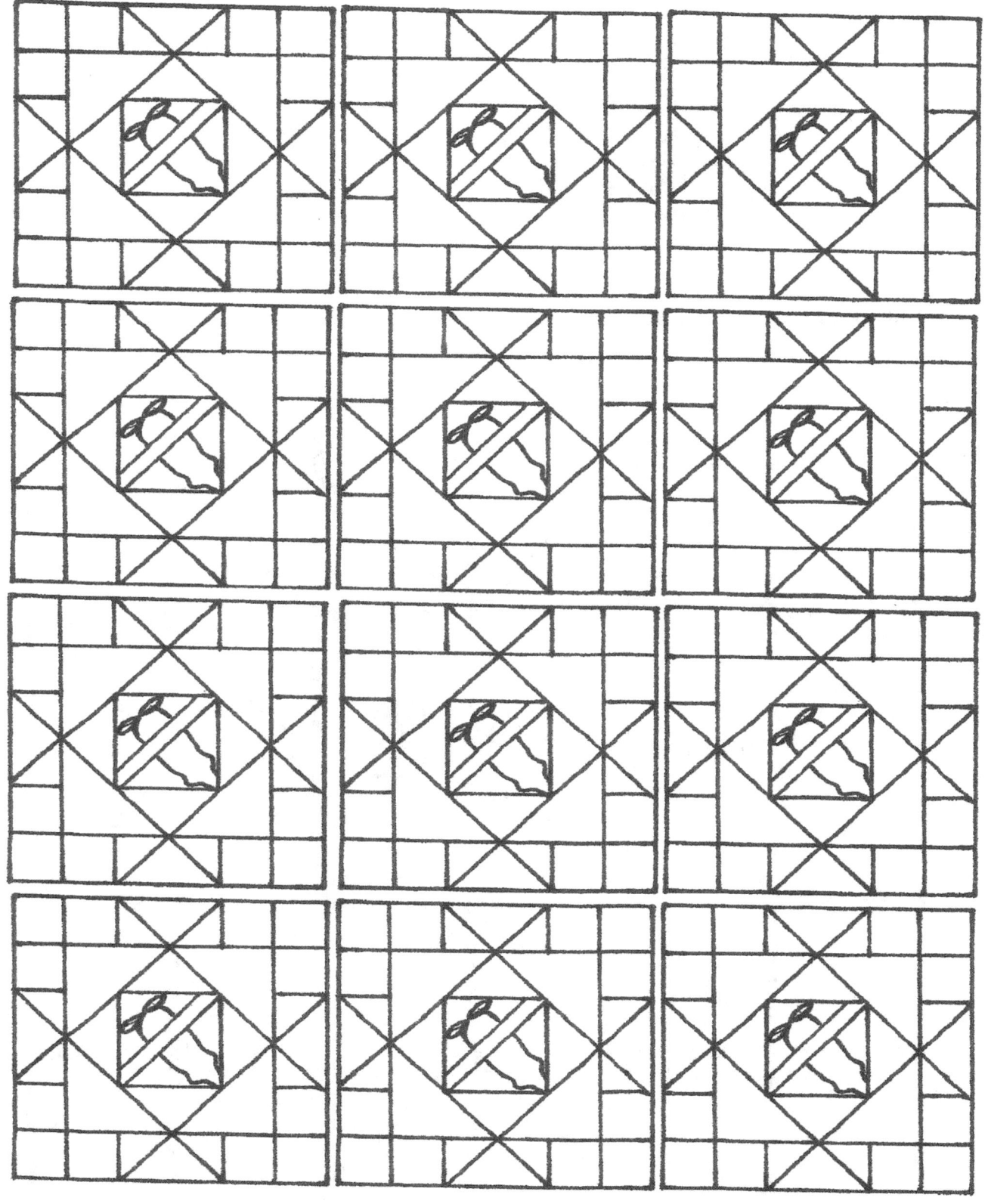

Barn Quilt Peterson Century Feeder
Shawano County Wisconsin Barn Quilts

Barn Located
County Rd C
Clintonville, Wisconsin

Wisconsin Barn Quilt Peterson Century Feeder

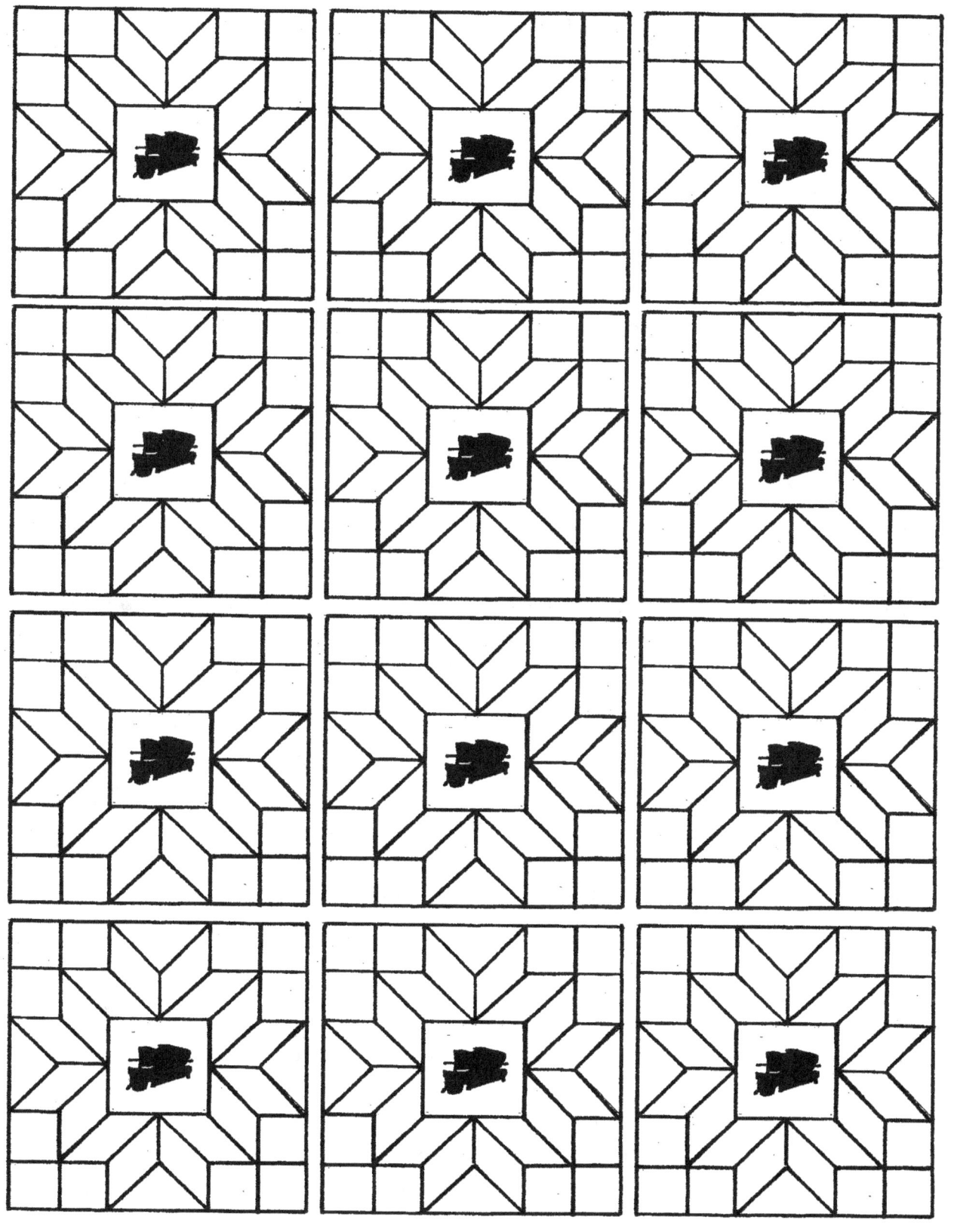

Barn Quilt Phoenix
Shawano County Wisconsin Barn Quilts

Barn Located
Old Highway 47
Pulaski, Wisconsin

Wisconsin Barn Quilt Phoenix

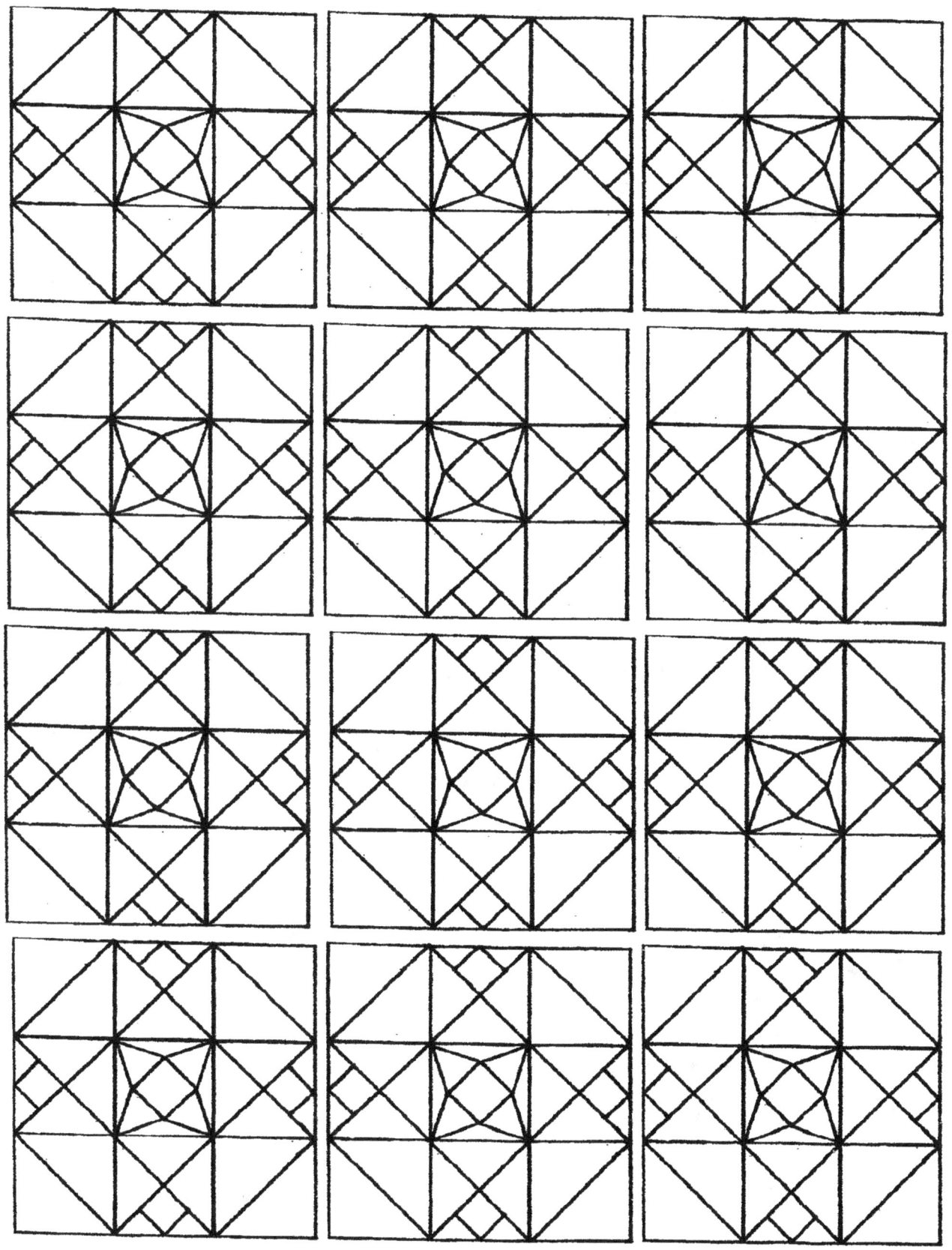

Barn Quilt Just Because
Shawano County Wisconsin Barn Quilts

Barn Located
East Freeborn St
Cecil, Wisconsin

Wisconsin Barn Quilt Just Because

Barn Quilt Star of Empire
Shawano County Wisconsin Barn Quilts

Barn Located
Burma Road
Marion, Wisconsin

Wisconsin Barn Quilt Star of Empire

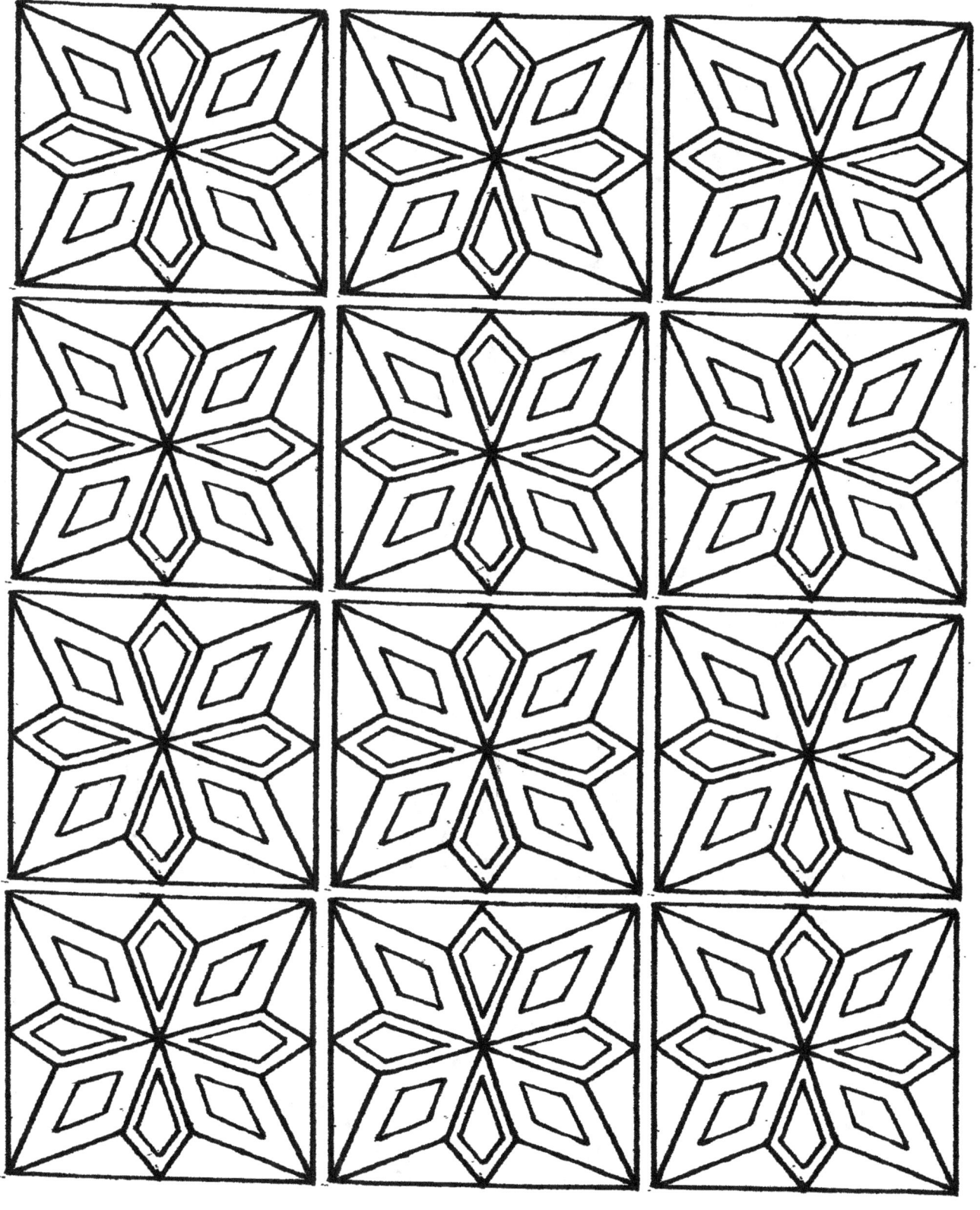

Barn Quilt Grandmother's Own
Shawano County Wisconsin Barn Quilts

Barn Located
Meadow Lane
Shawano, Wisconsin

Wisconsin Barn Quilt Grandmother's Own

Barn Quilt Cross
Shawano County Wisconsin Barn Quilts

Barn Located
Maple Lane
Tigerton, Wisconsin

Wisconsin Barn Quilt Cross

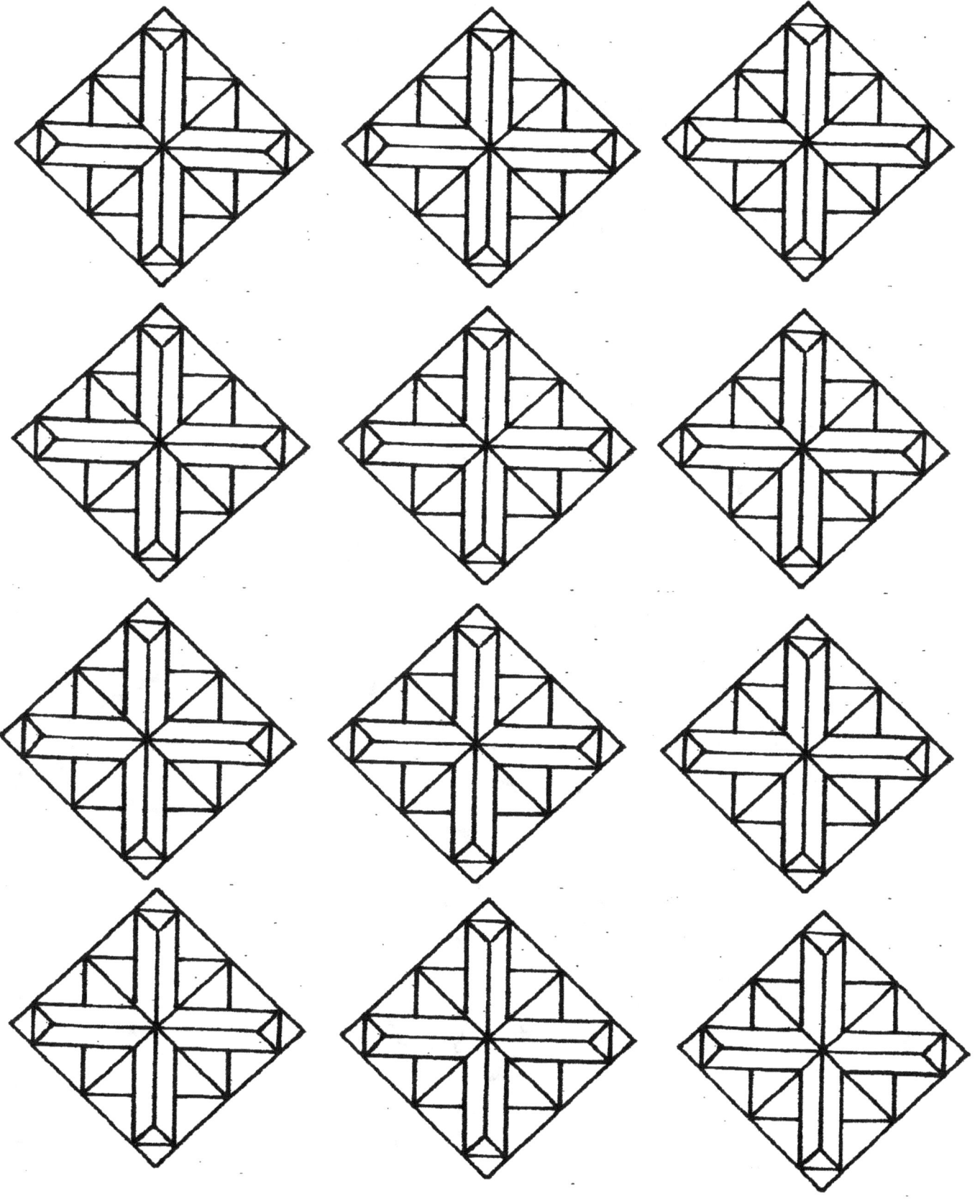

Barn Quilt North Star
Shawano County Wisconsin Barn Quilts

**Barn Located
State Highway 22
Shawano, Wisconsin**

Wisconsin Barn Quilt North Star

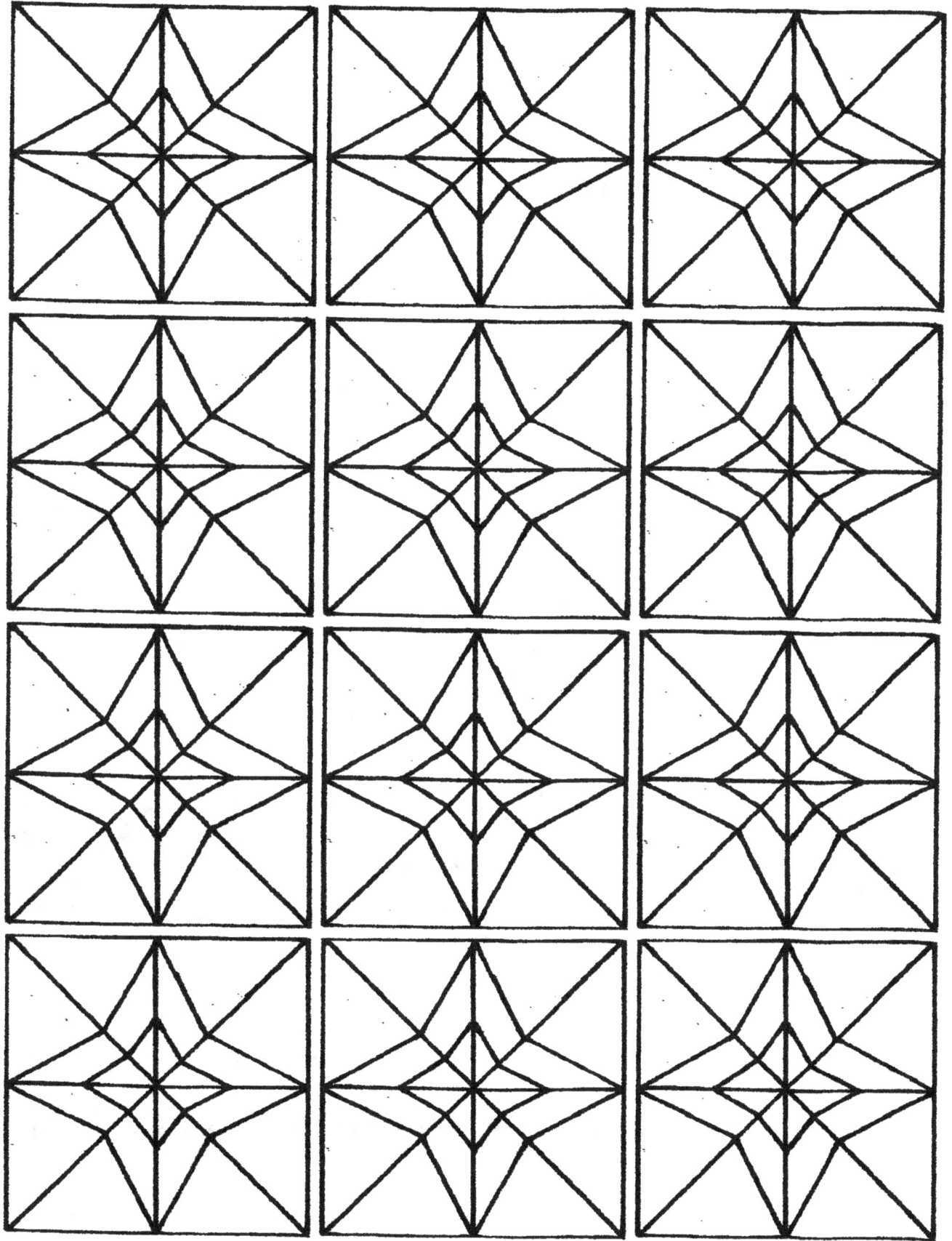

Barn Quilt Octagonal Star
Shawano County Wisconsin Barn Quilts

Barn Located
S. St Augustine Street
Pulaski, Wisconsin

Wisconsin Barn Quilt Octagonal Star

Barn Quilt Twisting Star
Shawano County Wisconsin Barn Quilts

Barn Located
State Hwy 153
Wittenberg, Wisconsin

Wisconsin Barn Quilt Twisting Star

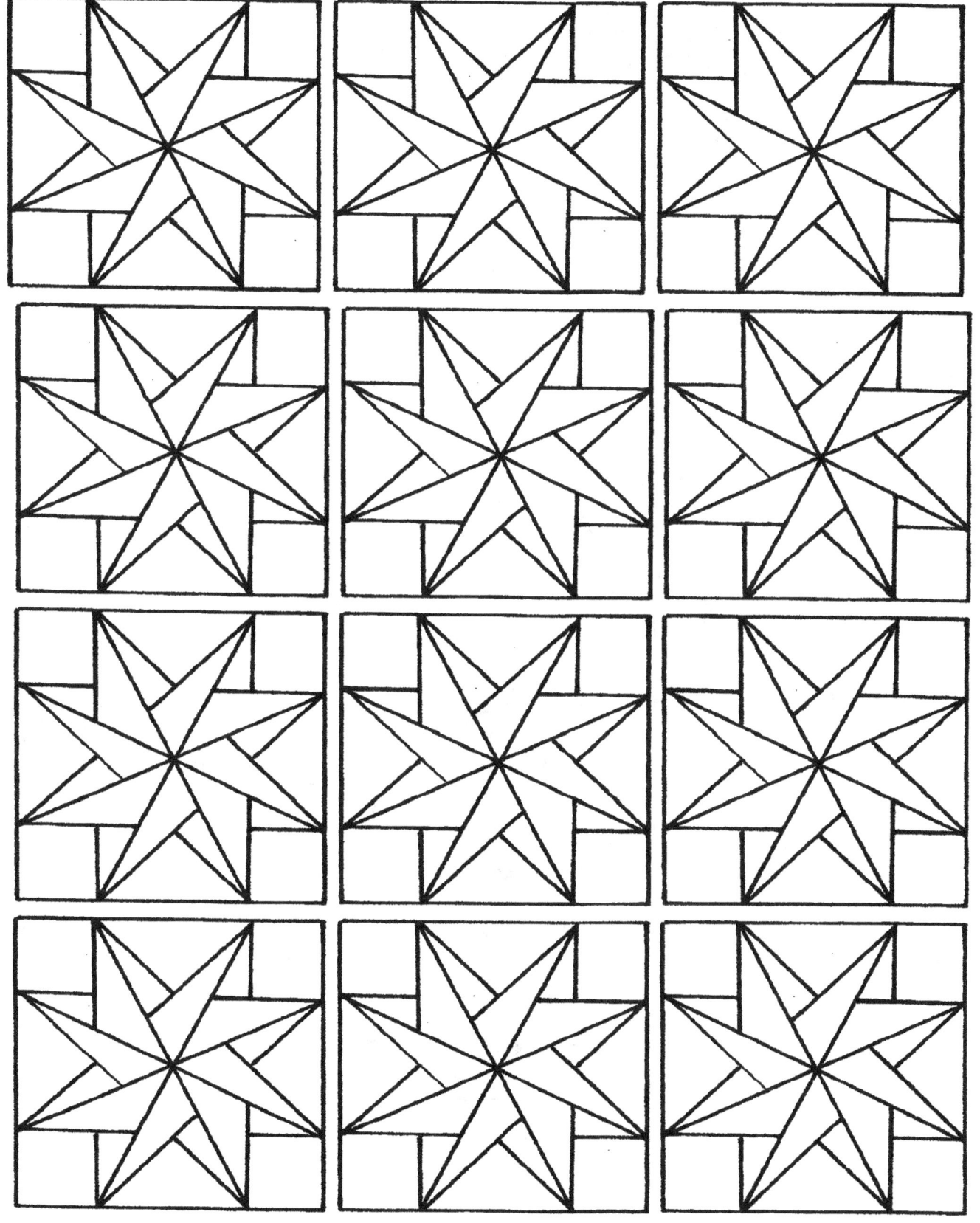

Barn Quilt Star Bound
Shawano County Wisconsin Barn Quilts

Barn Located
Willow Road
Pulaski, Wisconsin

Wisconsin Barn Quilt Star Bound

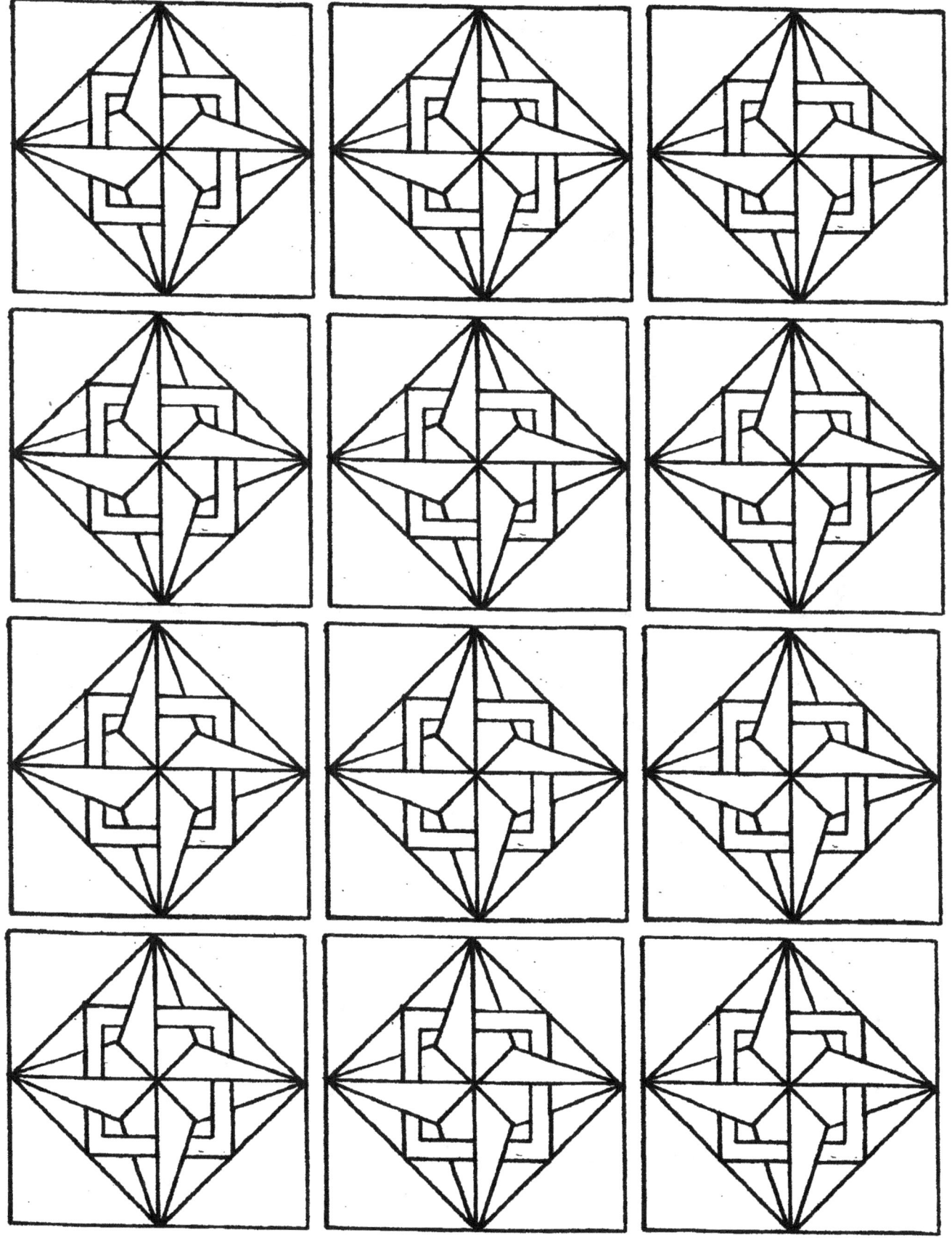

Barn Quilt Liberty Banner
Shawano County Wisconsin Barn Quilts

Barn Located
Belle Plaine Avenue
Shawano, Wisconsin

Wisconsin Barn Quilt Liberty Banner

Barn Quilt Pinwheel
Shawano County Wisconsin Barn Quilts

Barn Located
Beech Drive
Bonduel, Wisconsin

Wisconsin Barn Quilt Pinwheel

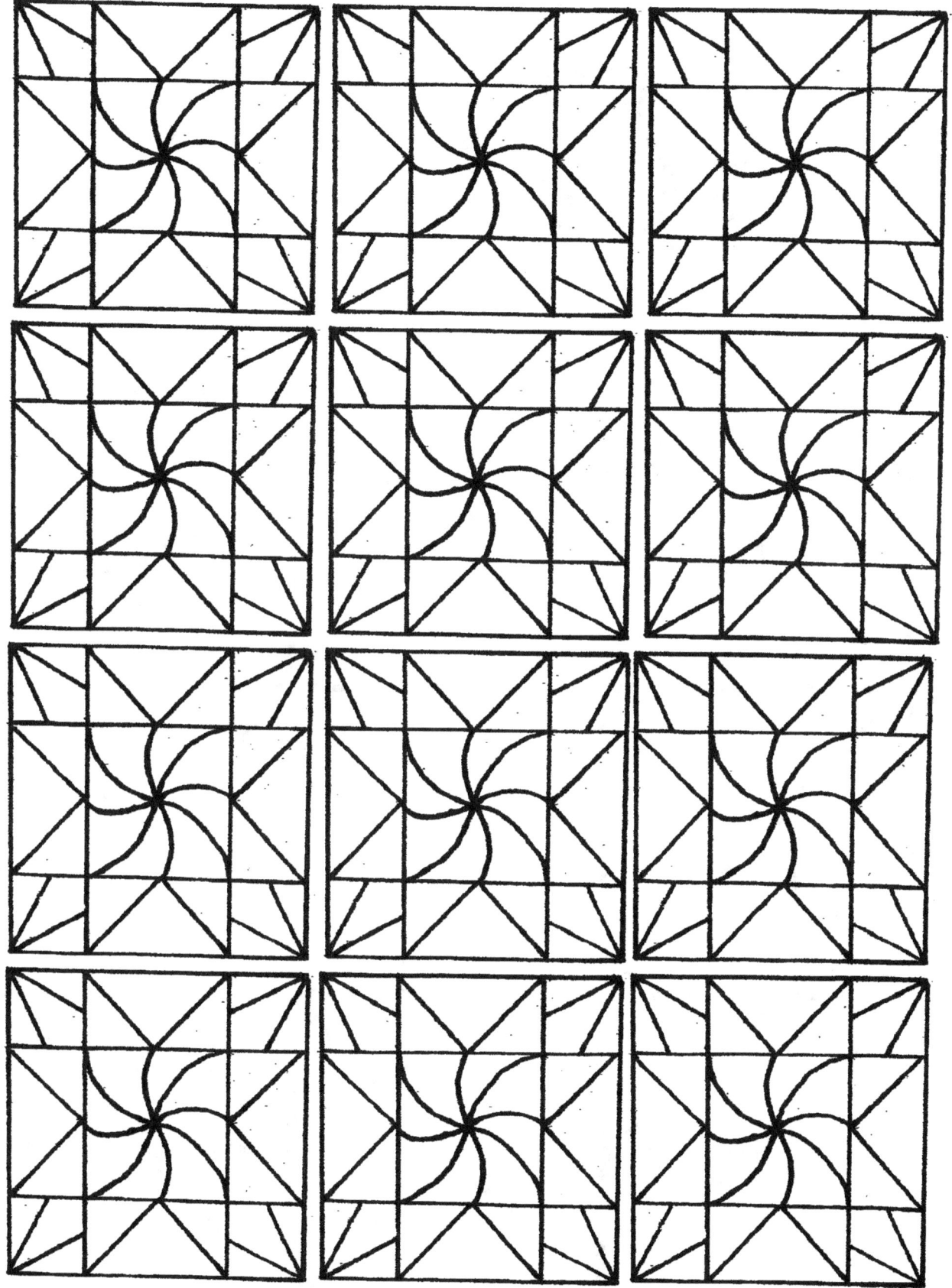

Barn Quilt Rainbow Paradox
Shawano County Wisconsin Barn Quilts

Barn Located
Green Valley Road
Krakow, Wisconsin

Wisconsin Barn Quilt Rainbow Paradox

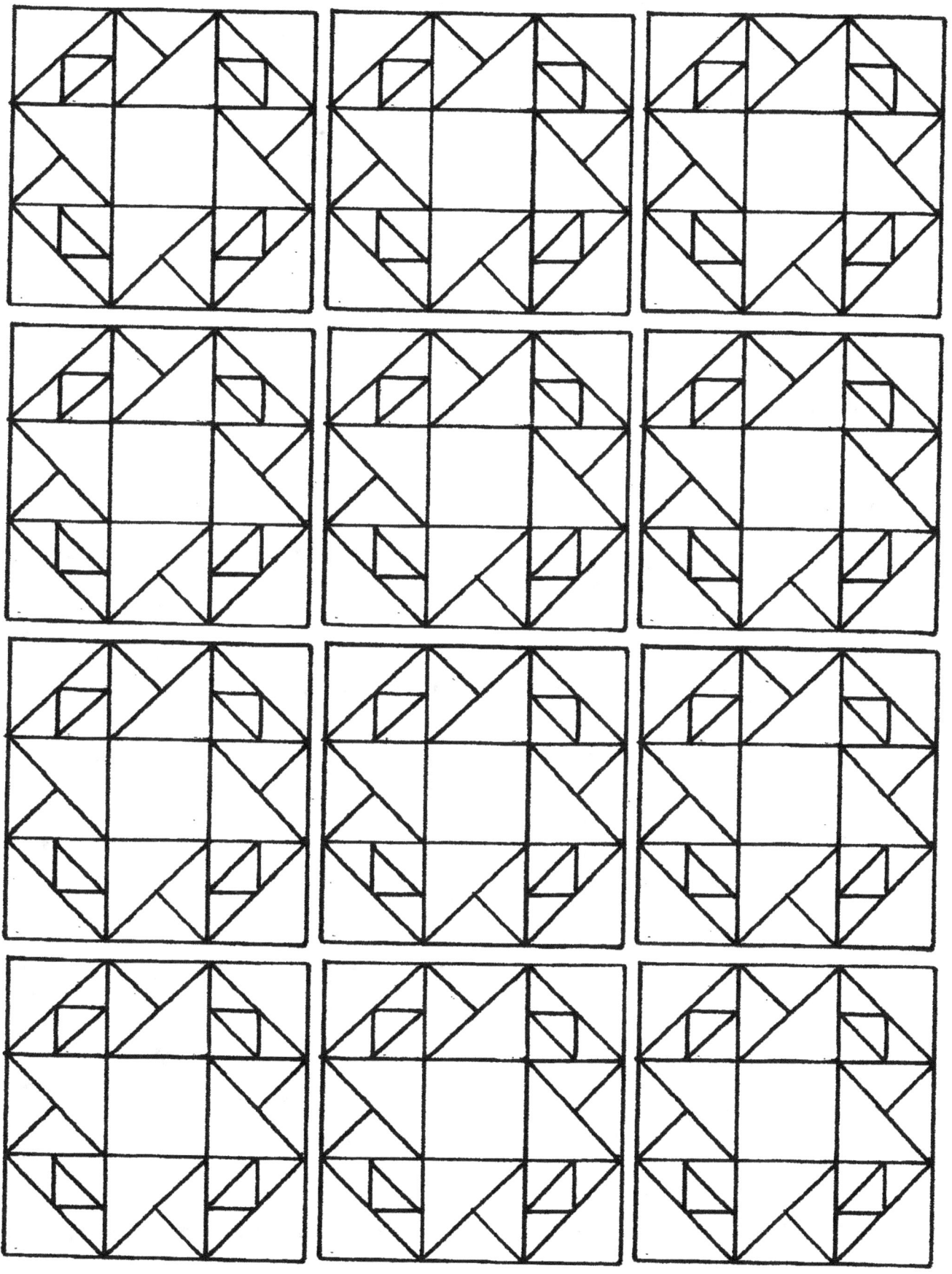

Barn Quilt Quarterfoils
Shawano County Wisconsin Barn Quilts

**Barn Located
County Road M
Shawano, Wisconsin**

Wisconsin Barn Quilt Quarterfoils

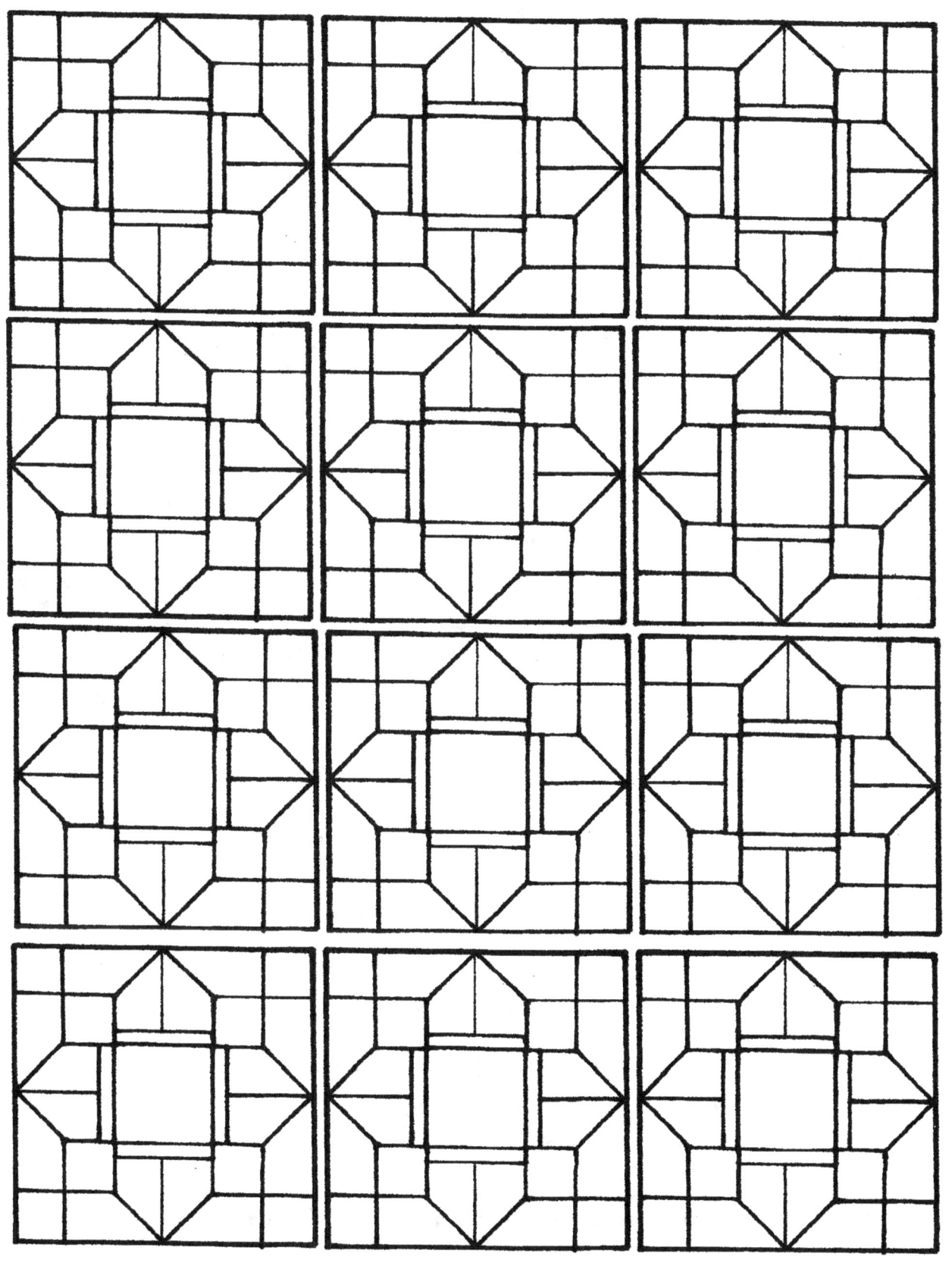

Barn Quilt Gentleman's Fancy
Shawano County Wisconsin Barn Quilts

**Barn Located
County Road BE
Bonduel, Wisconsin**

Wisconsin Barn Quilt Gentleman's Fancy

Barn Quilt Patriotic Star
Shawano County Wisconsin Barn Quilts

Barn Located
Broadway
Shawano, Wisconsin

Wisconsin Barn Quilt Patriotic Star

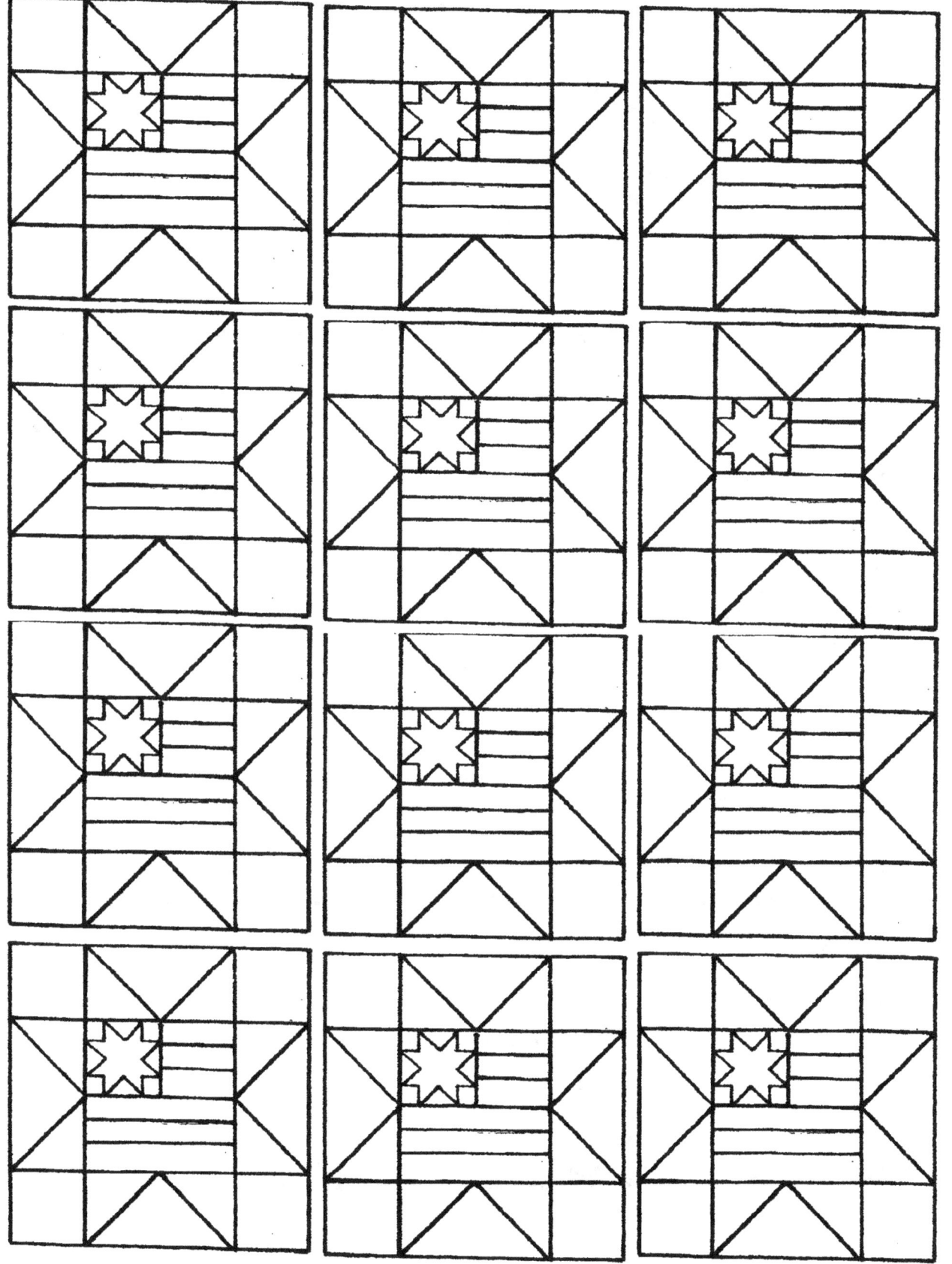

Barn Quilt Garden Square
Shawano County Wisconsin Barn Quilts

Barn Located
State Hwy 29
Pulaski, Wisconsin

Wisconsin Barn Quilt Garden Square

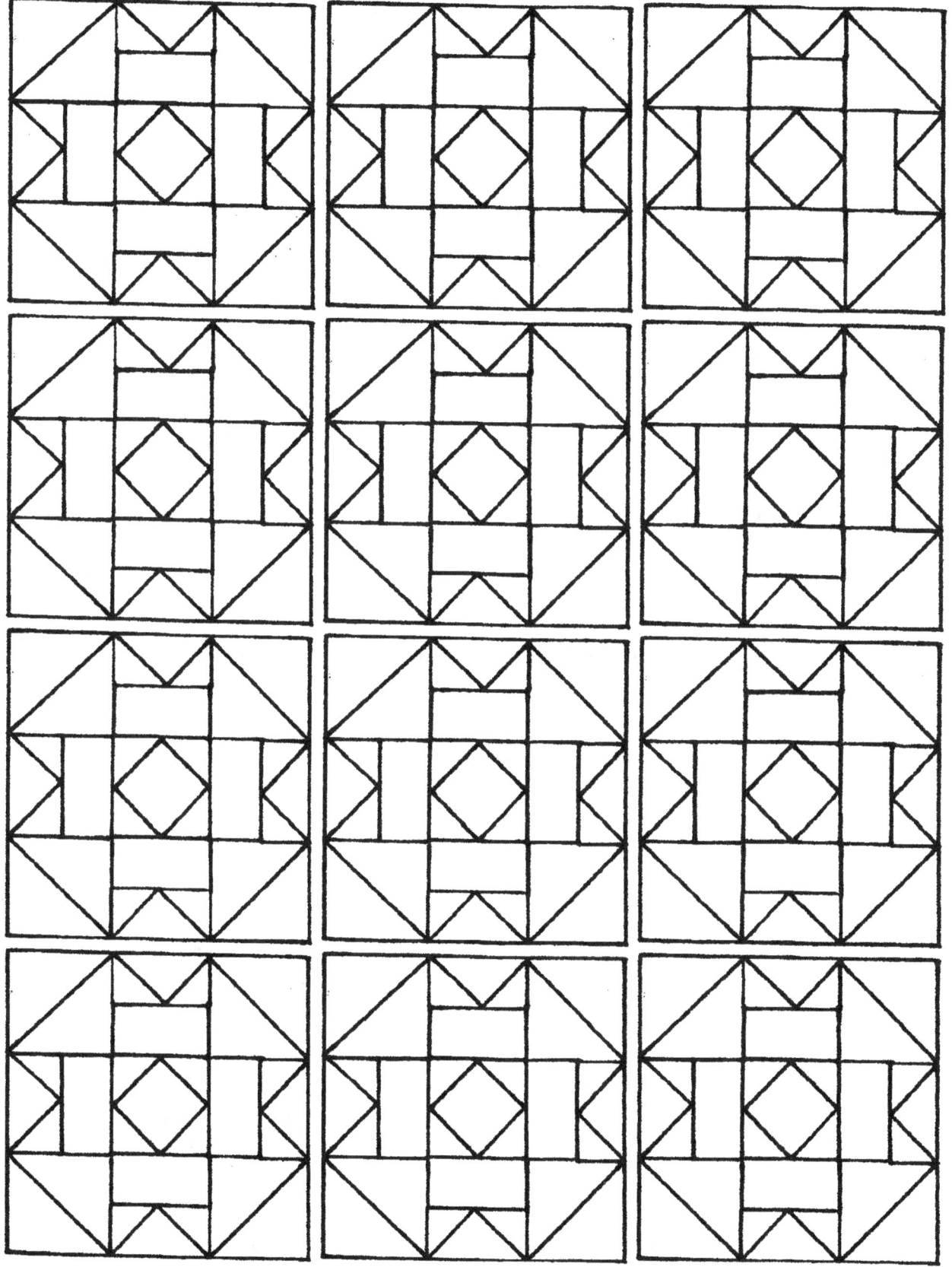

Barn Quilt Pinwheel Flag
Shawano County Wisconsin Barn Quilts

Barn Located
Old Lake Road
Shawano, Wisconsin

Wisconsin Barn Quilt Pinwheel Flag

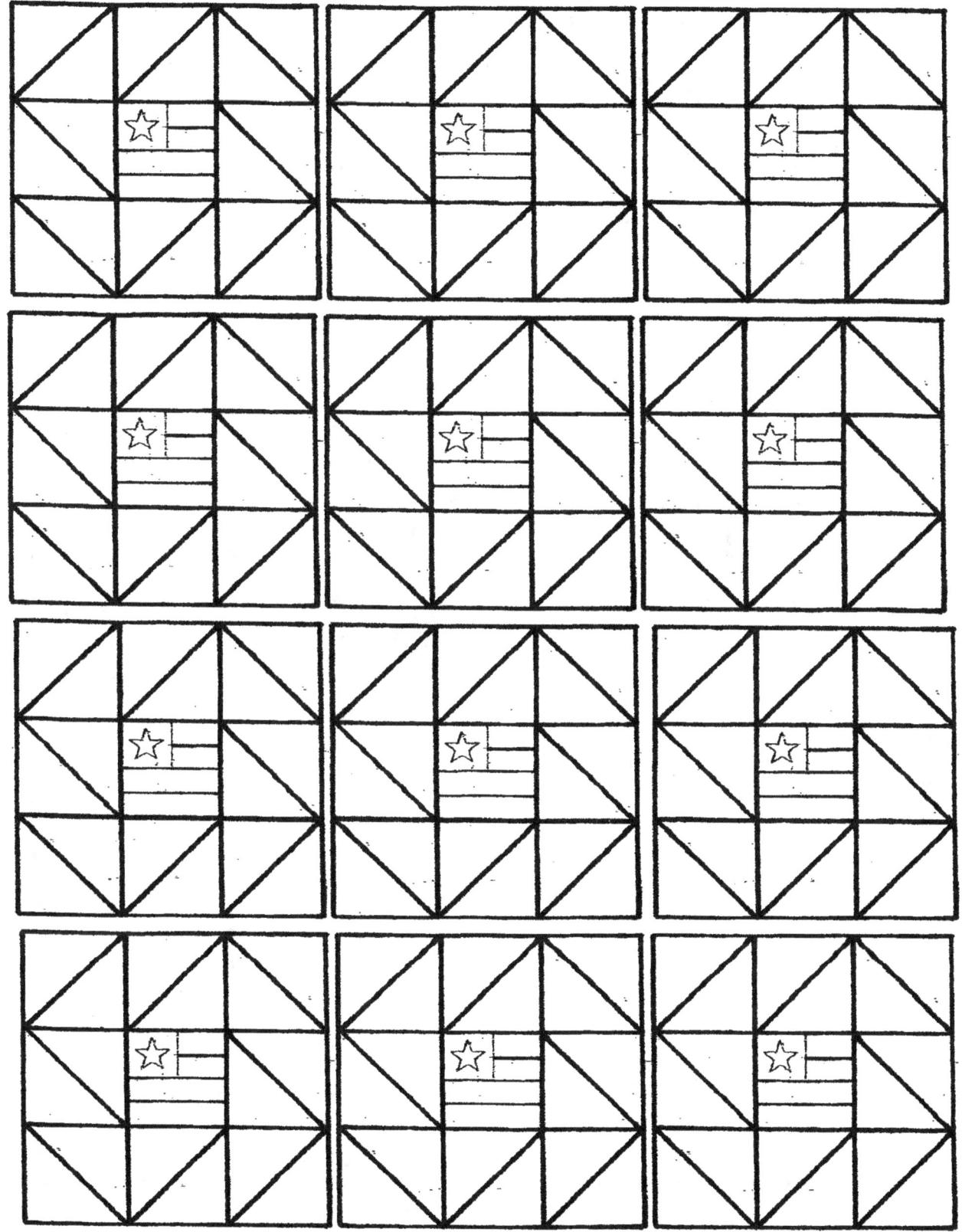

Barn Quilt Friendship Star
Shawano County Wisconsin Barn Quilts

Barn Located
Swamp Road
Bonduel, Wisconsin

Wisconsin Barn Quilt Friendship Star

Barn Quilt Patchwork Pines
Shawano County Wisconsin Barn Quilts

Barn Located
Spruce Road
Shawano, Wisconsin

Wisconsin Barn Quilt Patchwork Pines

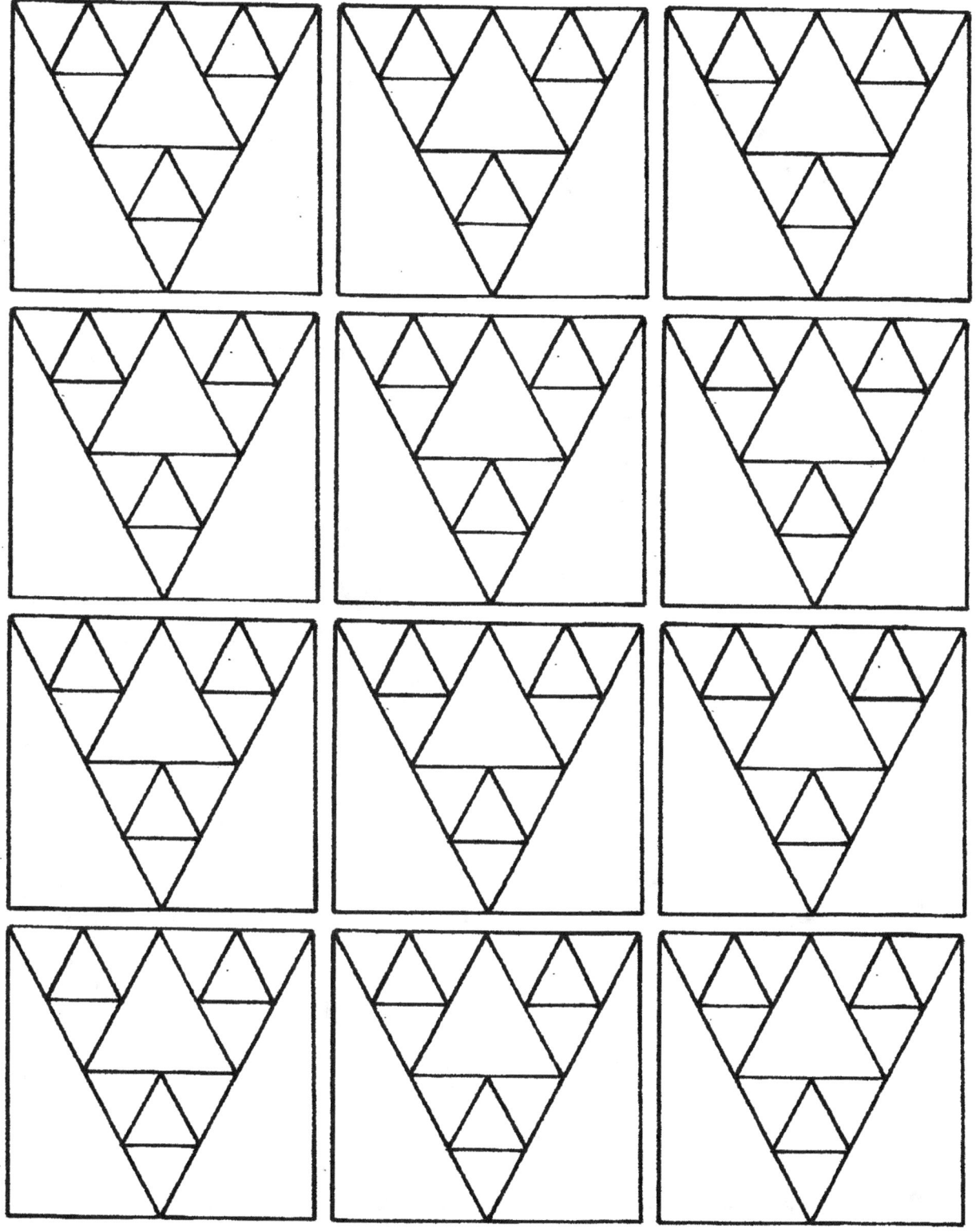

Barn Quilt Card Basket
Shawano County Wisconsin Barn Quilts

Barn Located
Short Lane
Eland, Wisconsin

Wisconsin Barn Quilt Card Basket

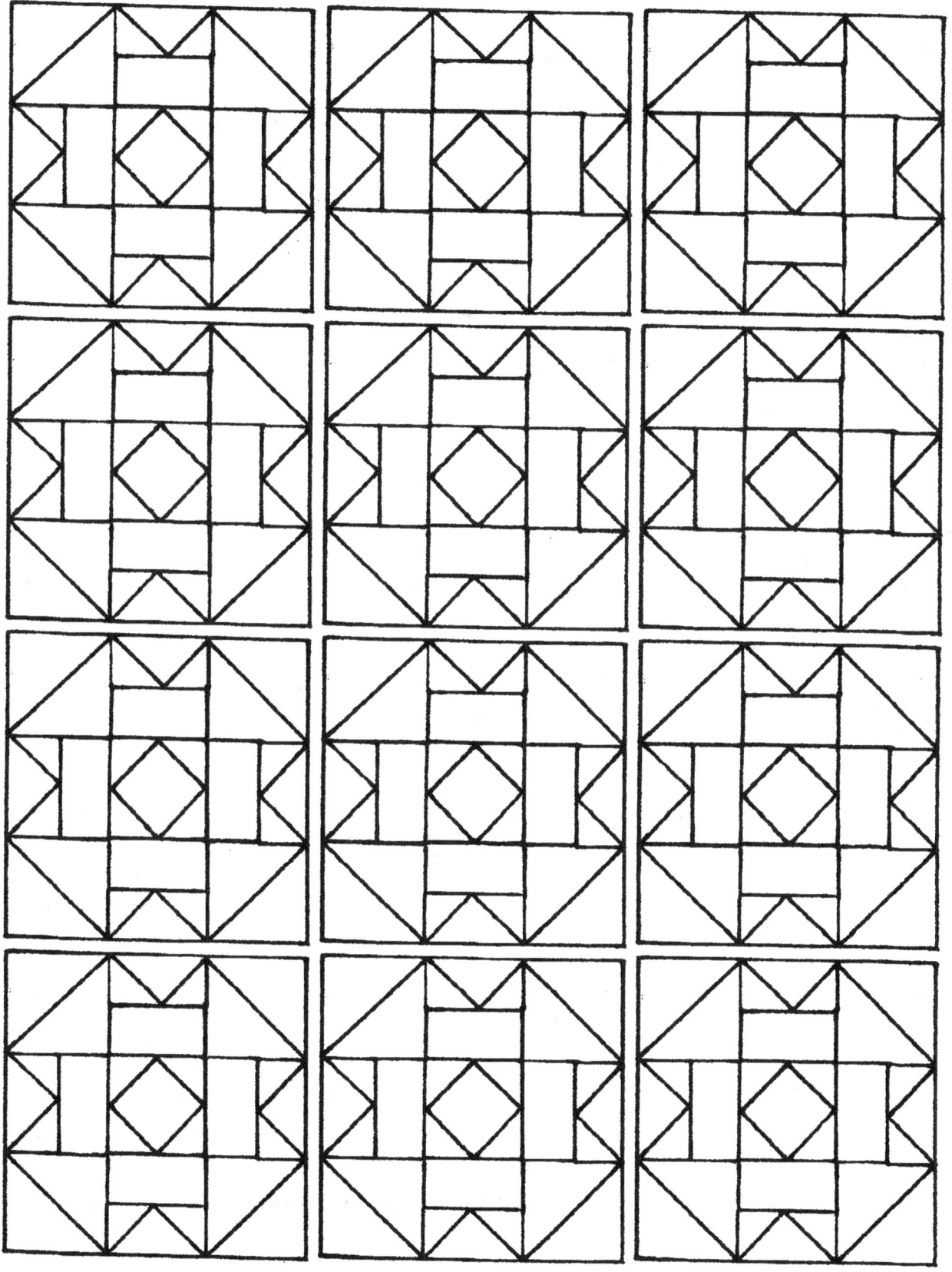

Barn Quilt Double Square
Shawano County Wisconsin Barn Quilts

Barn Located
Green Valley Road
Pulaski, Wisconsin

Wisconsin Barn Quilt Double Square

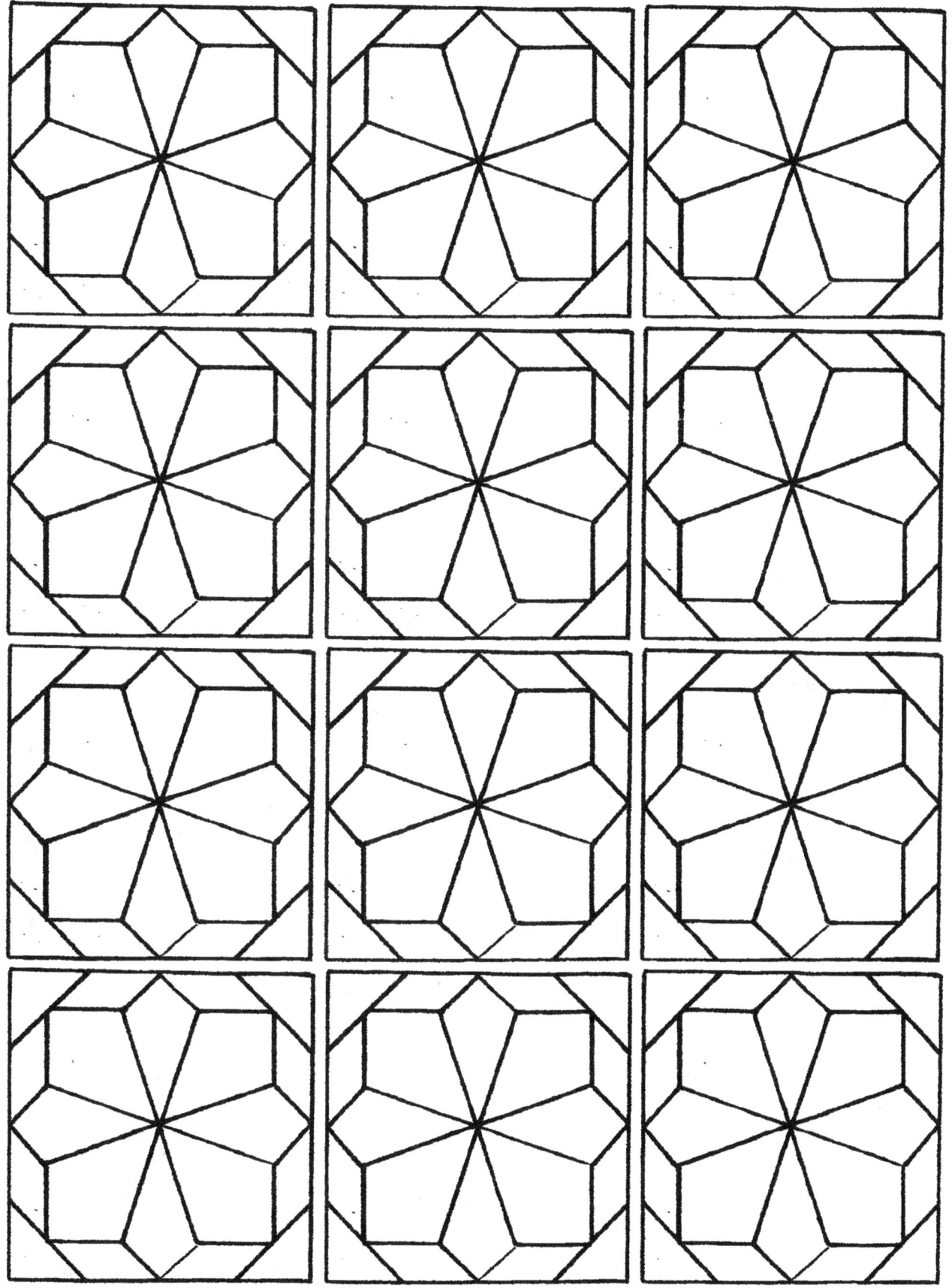

Barn Quilt Signs of Spring
Shawano County Wisconsin Barn Quilts

Barn Located
Angelica Drive
Krakow, Wisconsin

Wisconsin Barn Quilt Signs of Spring

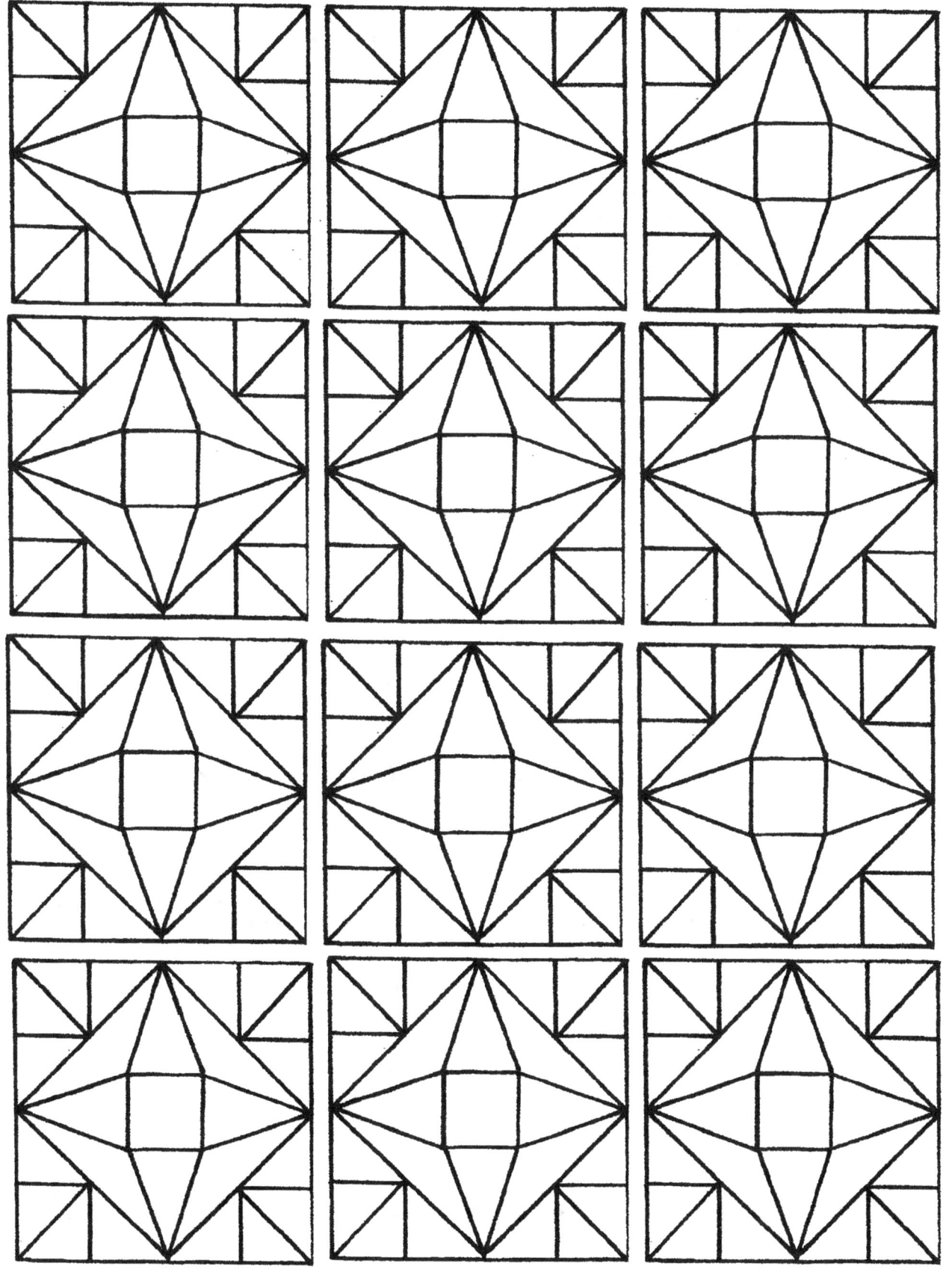

Barn Quilt Farmer's Family
Shawano County Wisconsin Barn Quilts

Barn Location
Kratzke Road
Clintonville, Wisconsin

Wisconsin Barn Quilt Farmer's Family

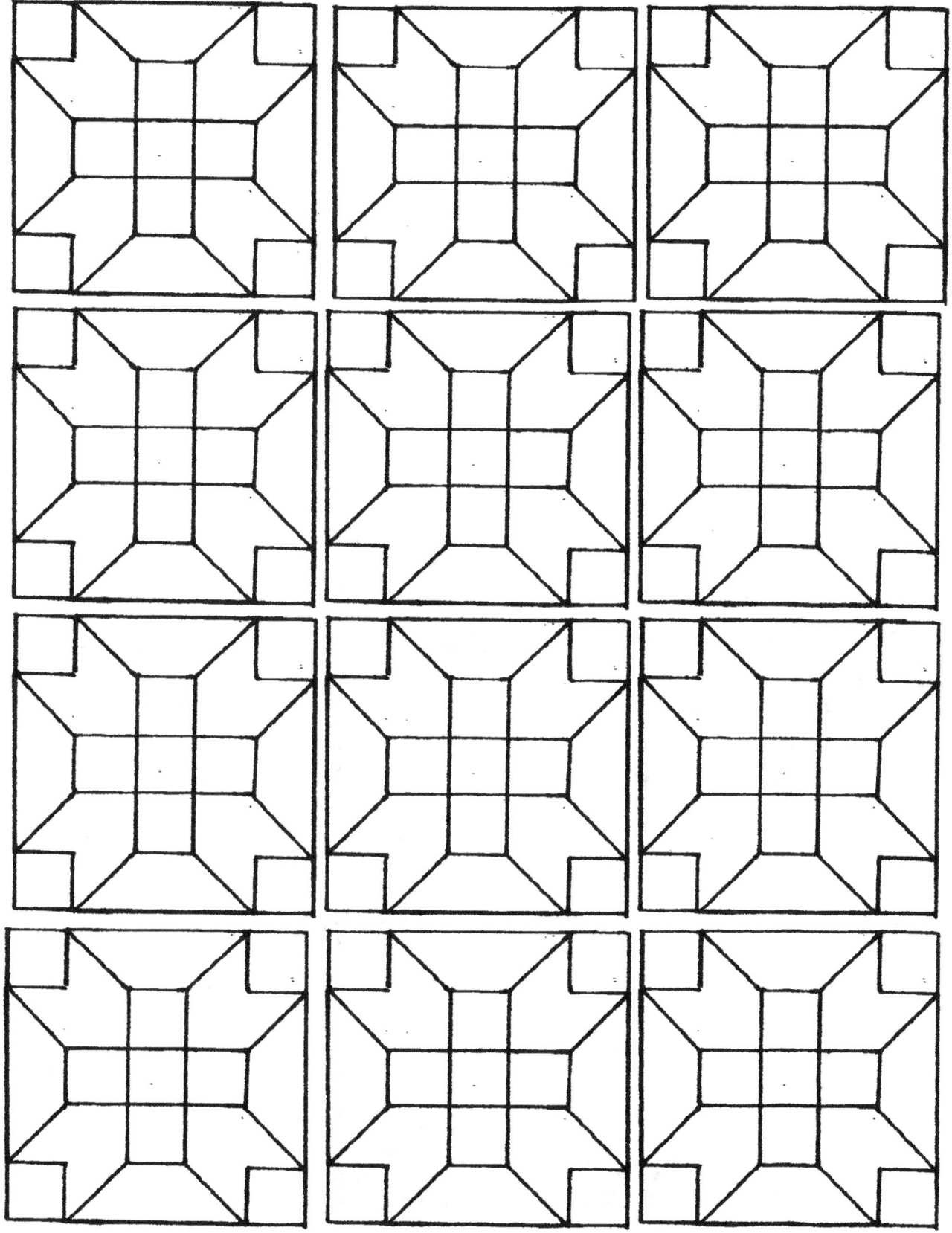

Barn Quilt Starshadow
Shawano County Wisconsin Barn Quilts

Barn Located
State Highway 156
Sciocton, Wisconsin

Wisconsin Barn Quilt Starshadow

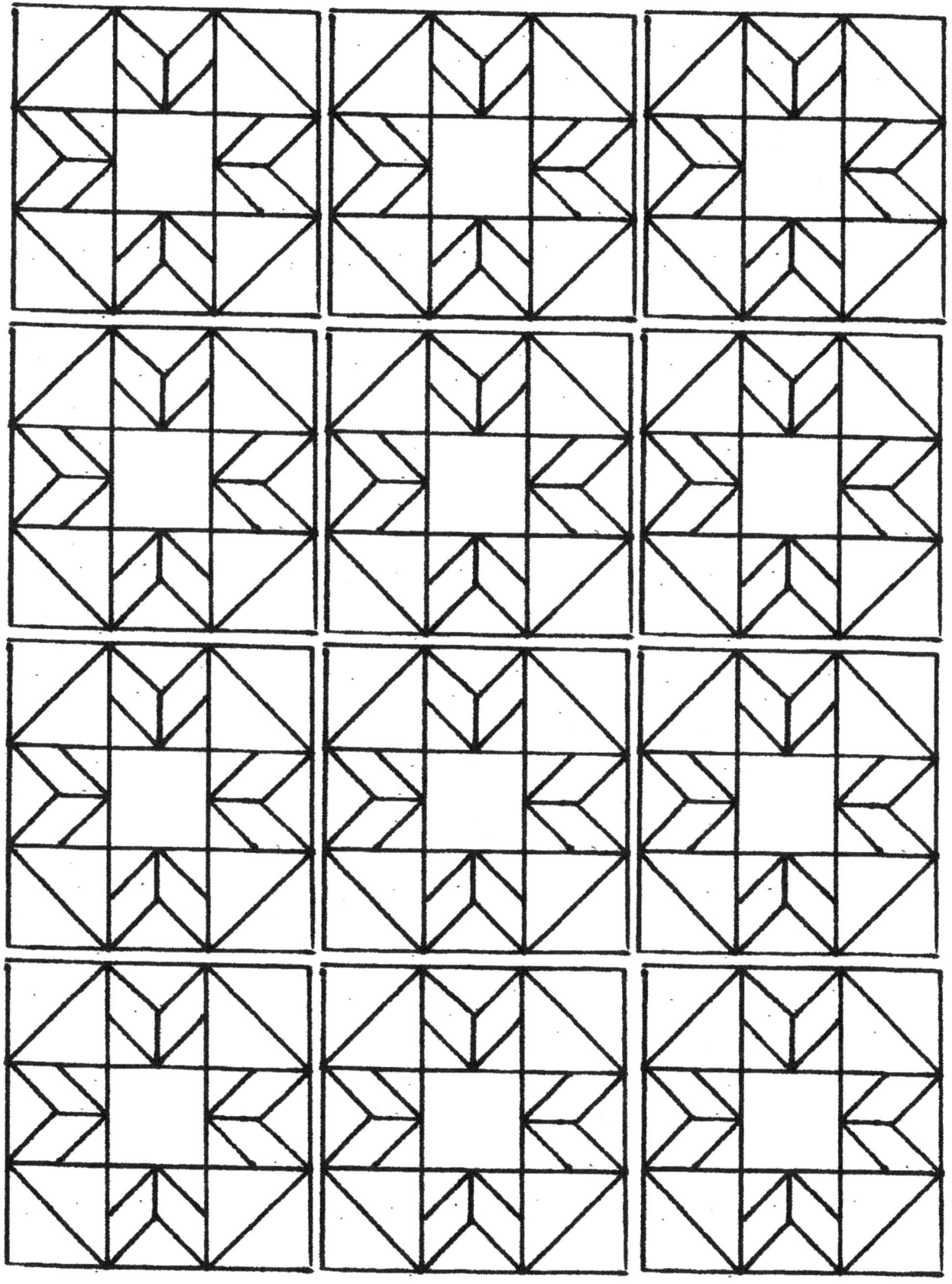

Barn Quilt Wishing Star
Shawano County Wisconsin Barn Quilts

Barn Located
County Road BE
Bonduel, Wisconsin

Wisconsin Barn Quilt Wishing Star

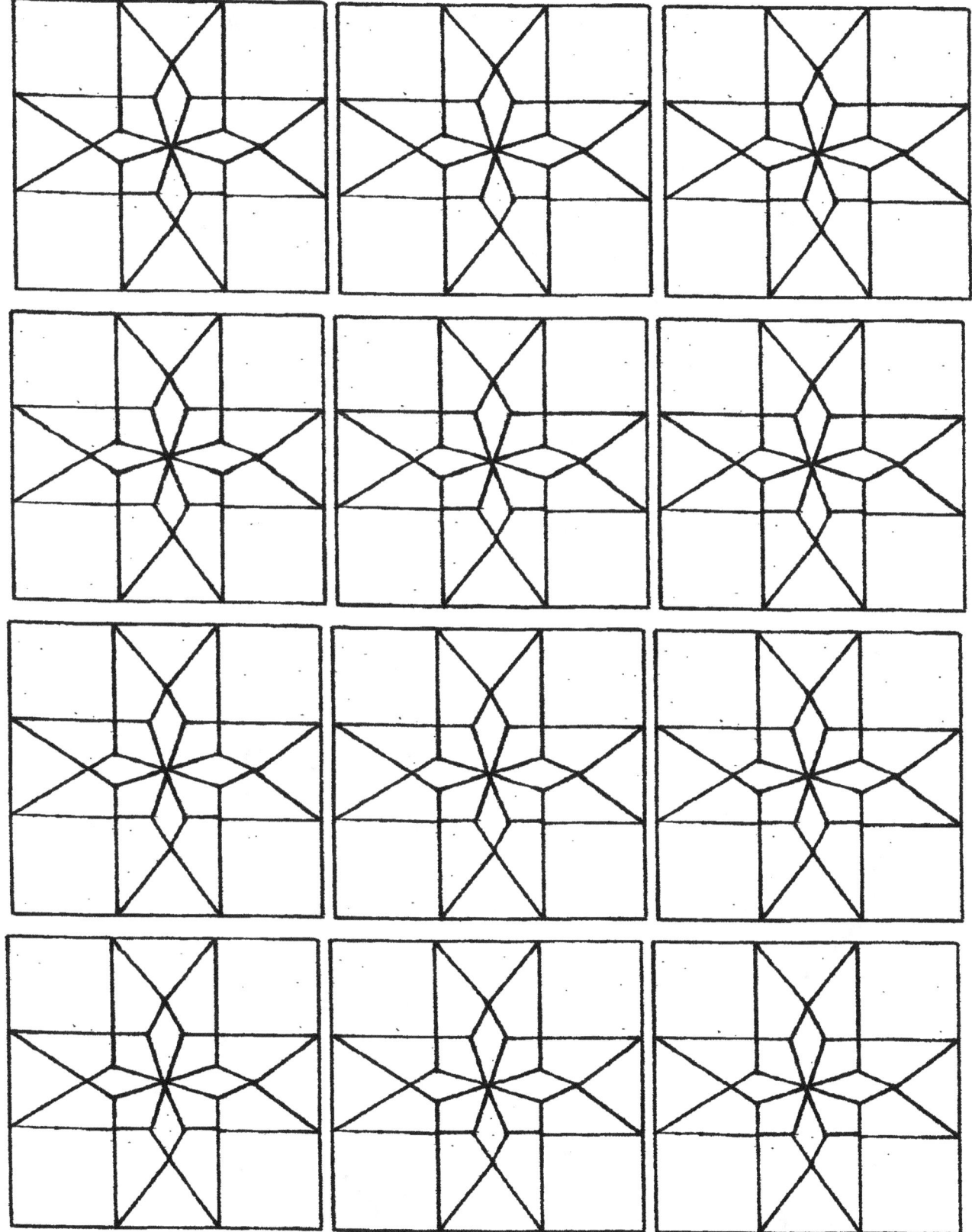

Barn Quilt Autumn's Rainbow
Shawano County Wisconsin Barn Quilts

Barn Location
County Road Z
Birnamwood, Wisconsin

Wisconsin Barn Quilt Autumn's Rainbow

Barn Quilt Summer Star Flower
Shawano County Wisconsin Barn Quilts

Barn Located
Maple Road
Seymour, Wisconsin

Wisconsin Barn Quilt Summer Star Flower

Barn Quilt Prairie Sunrise
Shawano County Wisconsin Barn Quilts

Barn Located
Oakcrest Drive
Bonduel, Wisconsin

Wisconsin Barn Quilt Praire Sunrise

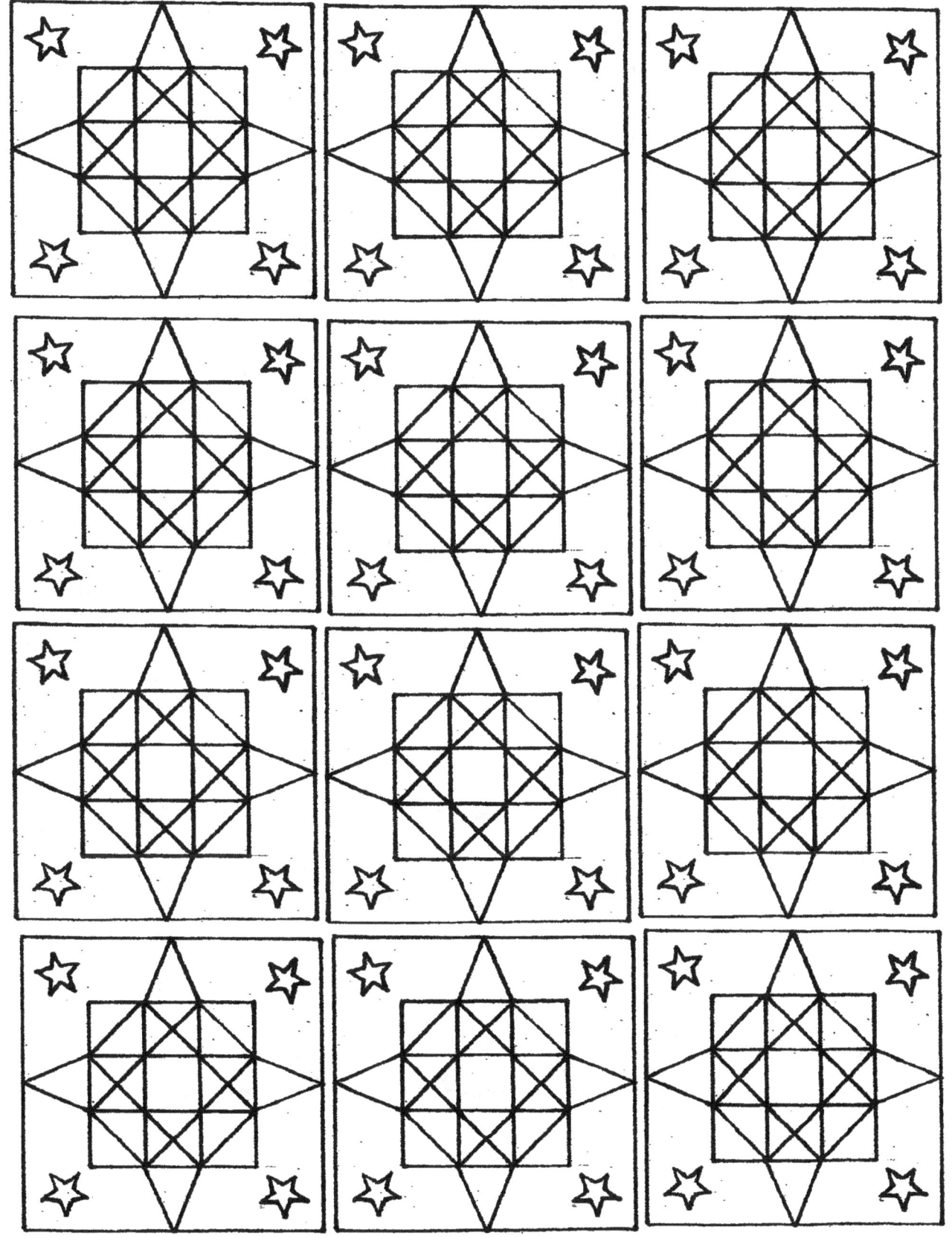

Barn Quilt Pumpkin Star
Shawano County Wisconsin Barn Quilts

Barn Located
Western Avenue
Birnamwood, Wisconsin

Wisconsin Barn Quilt Pumpkin Star

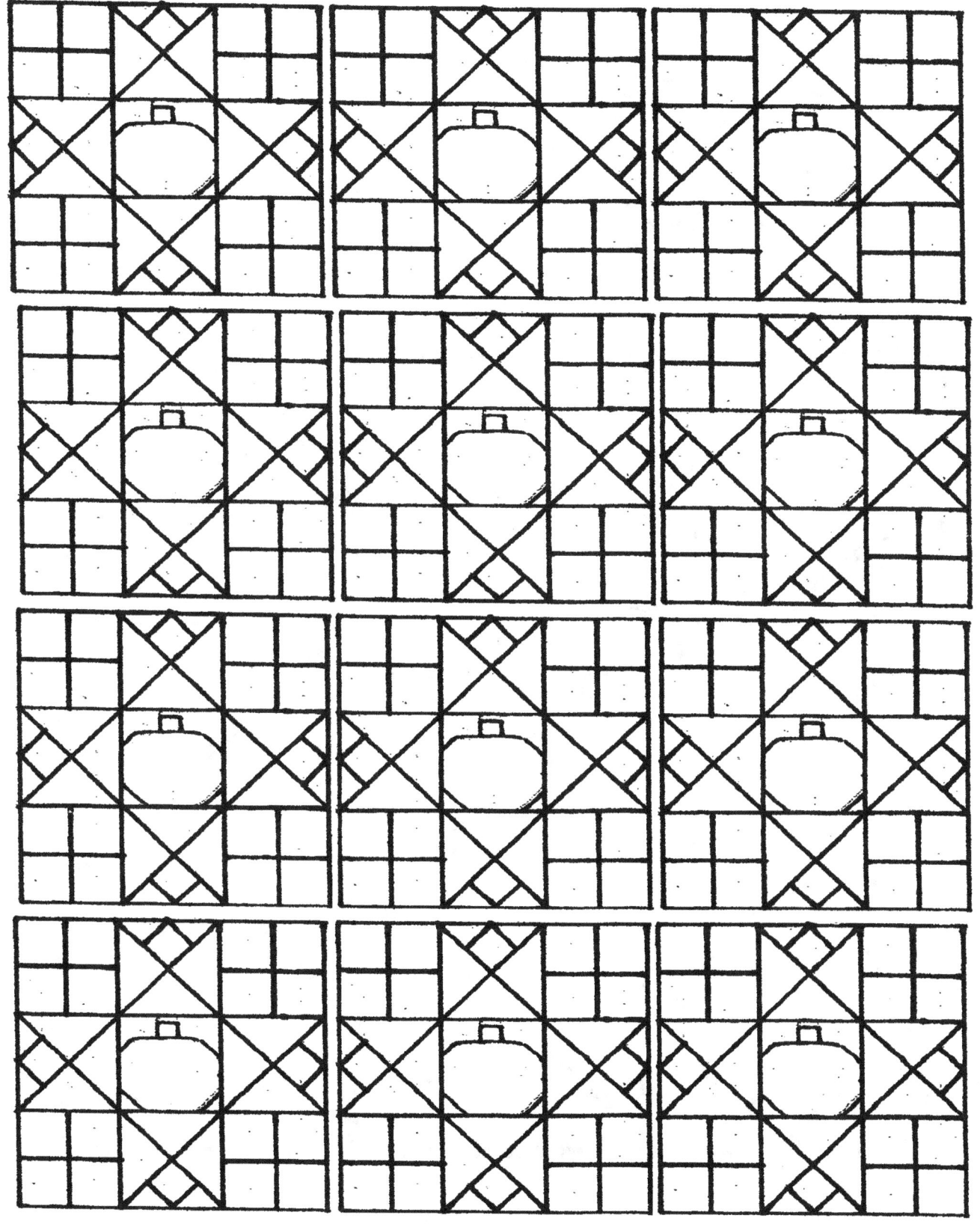

Barn Quilt Beran's Dairy
Shawano County Wisconsin Barn Quilts

Barn Location
Field Street
Birnamwood, Wisconsin

Wisconsin Barn Quilt Beran's Dairy

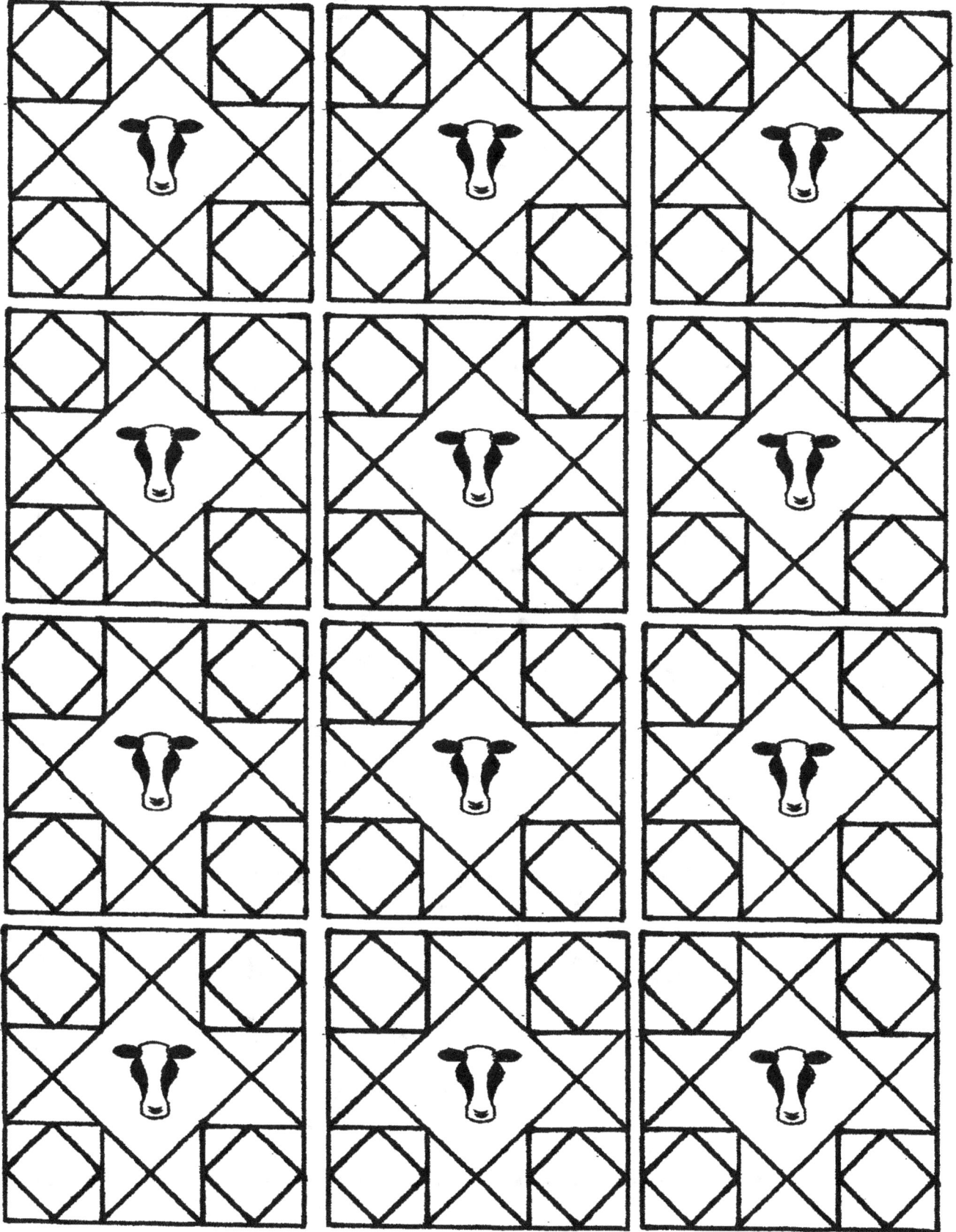

Barn Quilt Norwegian Pride
Shawano County Wisconsin Barn Quilts

Barn Located
Hemlock Road
Wittenberg, Wisconsin

Wisconsin Barn Quilt Norwegian Pride

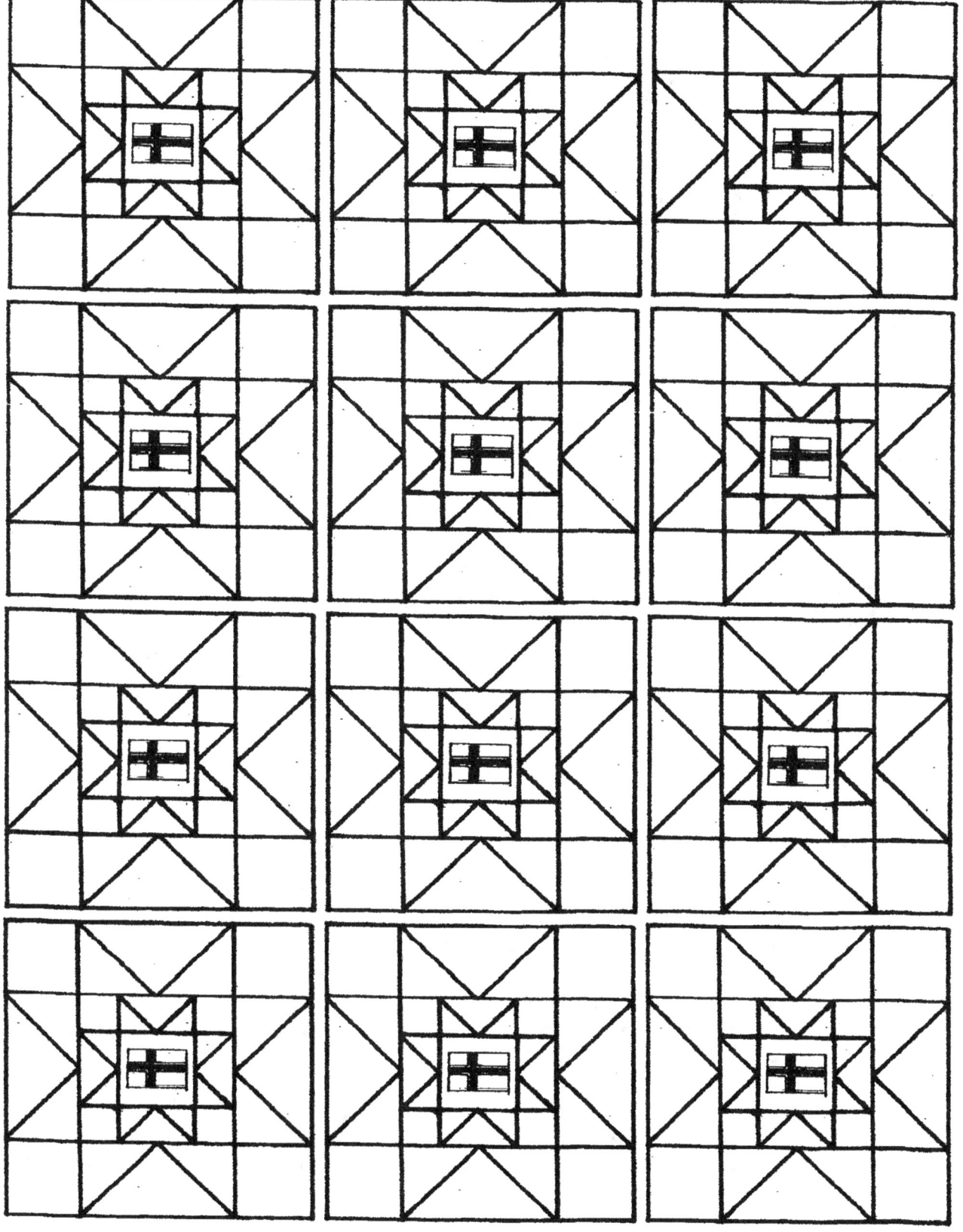

Barn Quilt Brown Swiz
Shawano County Wisconsin Barn Quilts

**Barn Located
Shorewood Lane
Clintonville, Wisconsin**

Wisconsin Barn Quilt Brown Swiz

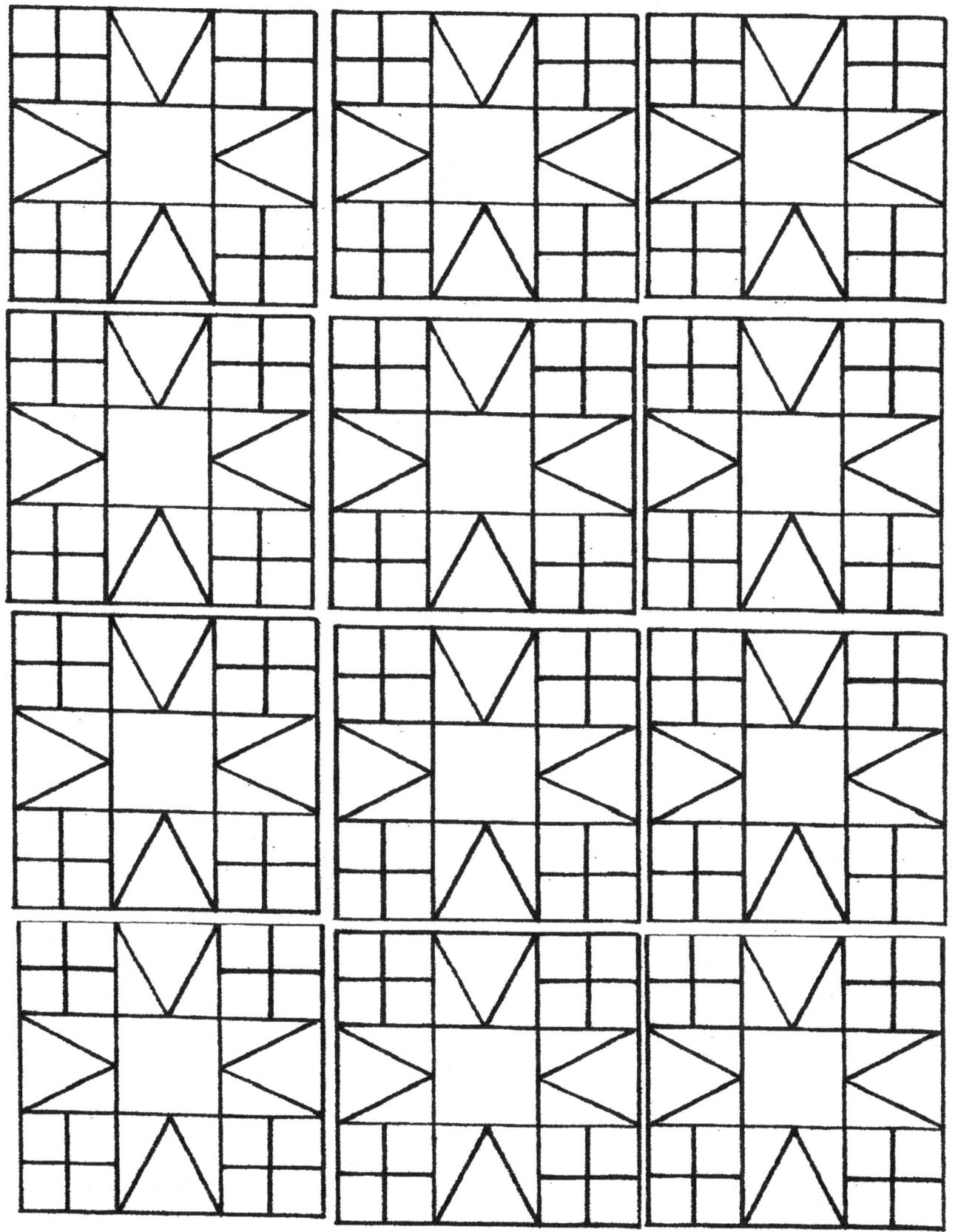

Barn Quilt Ornate Star
Shawano County Wisconsin Barn Quilts

Barn Located
Church Road
Birnamwood, Wisconsin

Wisconsin Barn Quilt Ornate Star

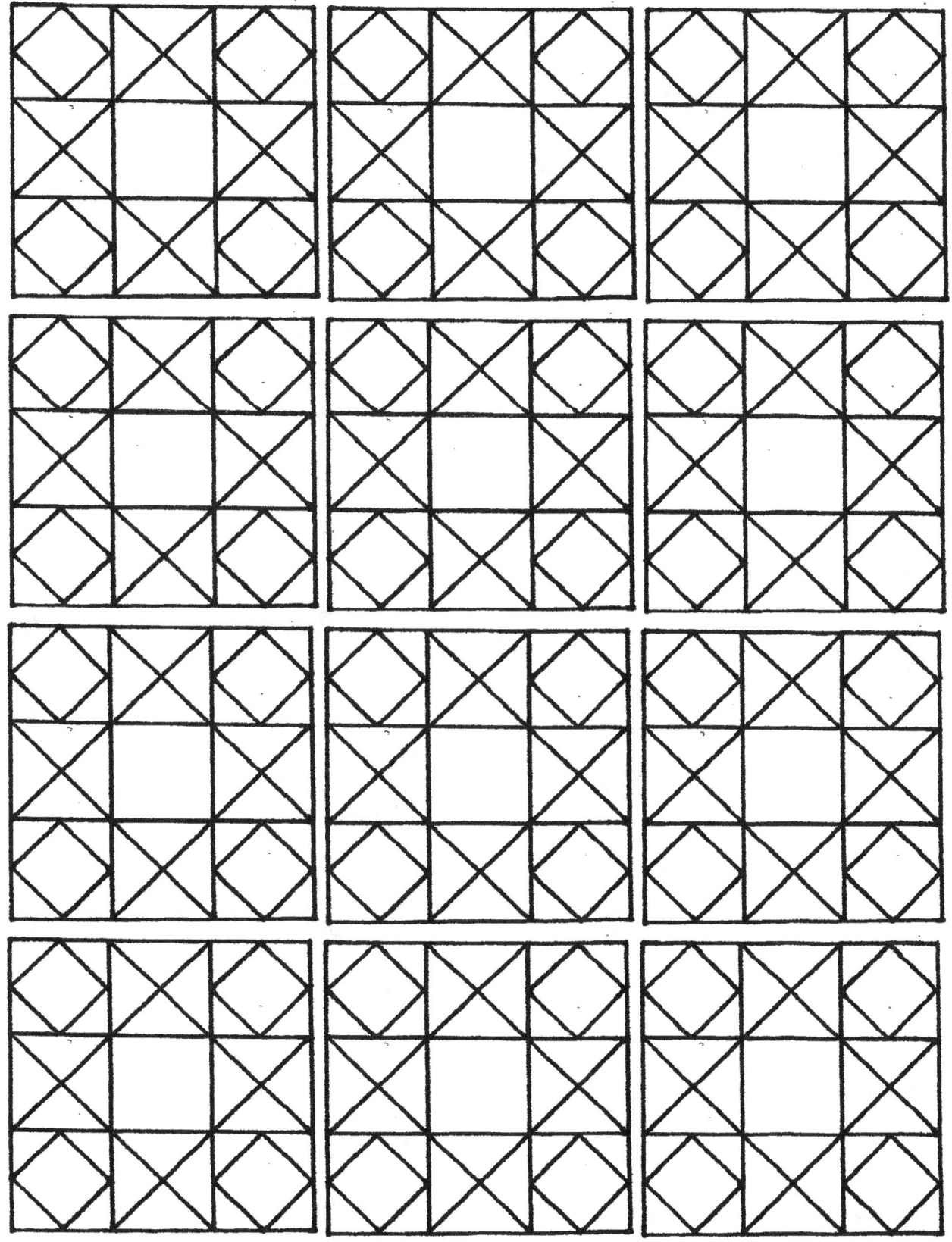

Barn Quilt Friendship Star
Shawano County Wisconsin Barn Quilts

Barn Located
Farmall Lane
Caroline, Wisconsin

Wisconsin Barn Quilt Friendship Star

Barn Quilt Rose Mosaic
Shawano County Wisconsin Barn Quilts

**Barn Located
Kolpack Road
Bowler, Wisconsin**

Wisconsin Barn Quilt Rose Mosaic

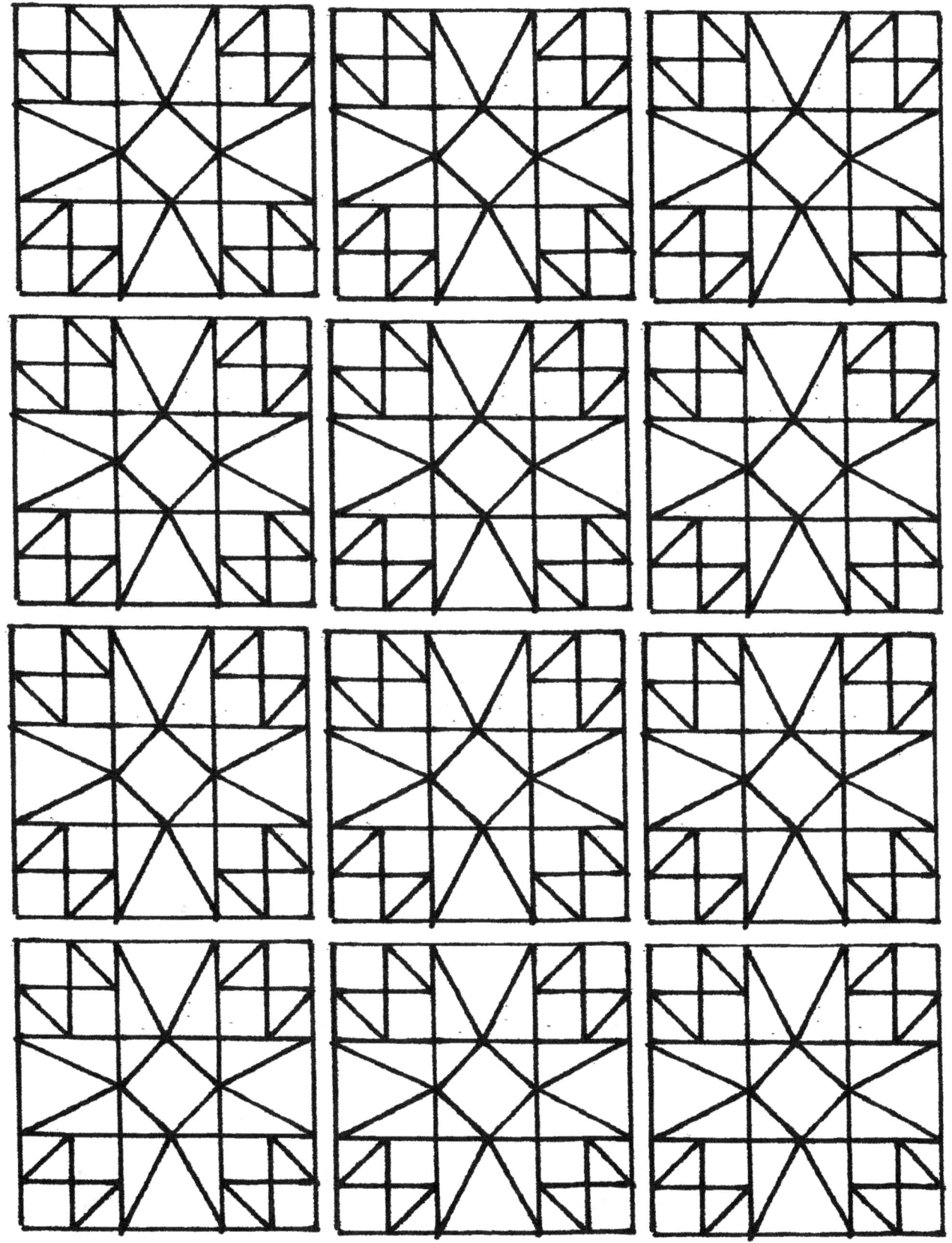

Barn Quilt All Points
Shawano County Wisconsin Barn Quilts

**Barn Located
Much Road
Tigerton, Wisconsin**

Wisconsin Barn Quilt All Points

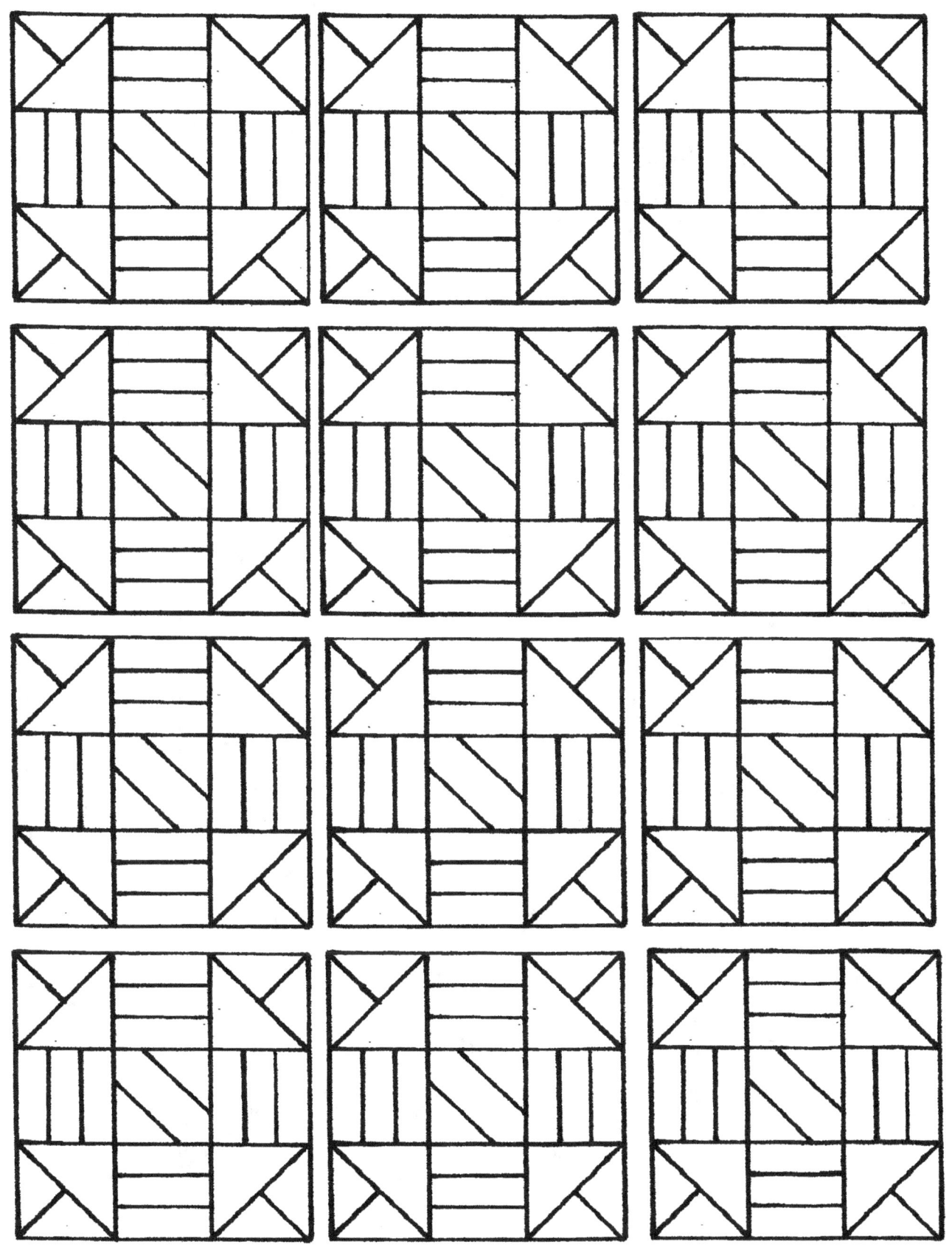

Barn Quilt Pinwheel Star
Shawano County Wisconsin Barn Quilts

Barn Located
Fair-Morr Road
Tigerton, Wisconsin

Wisconsin Barn Quilt Pinwheel Star

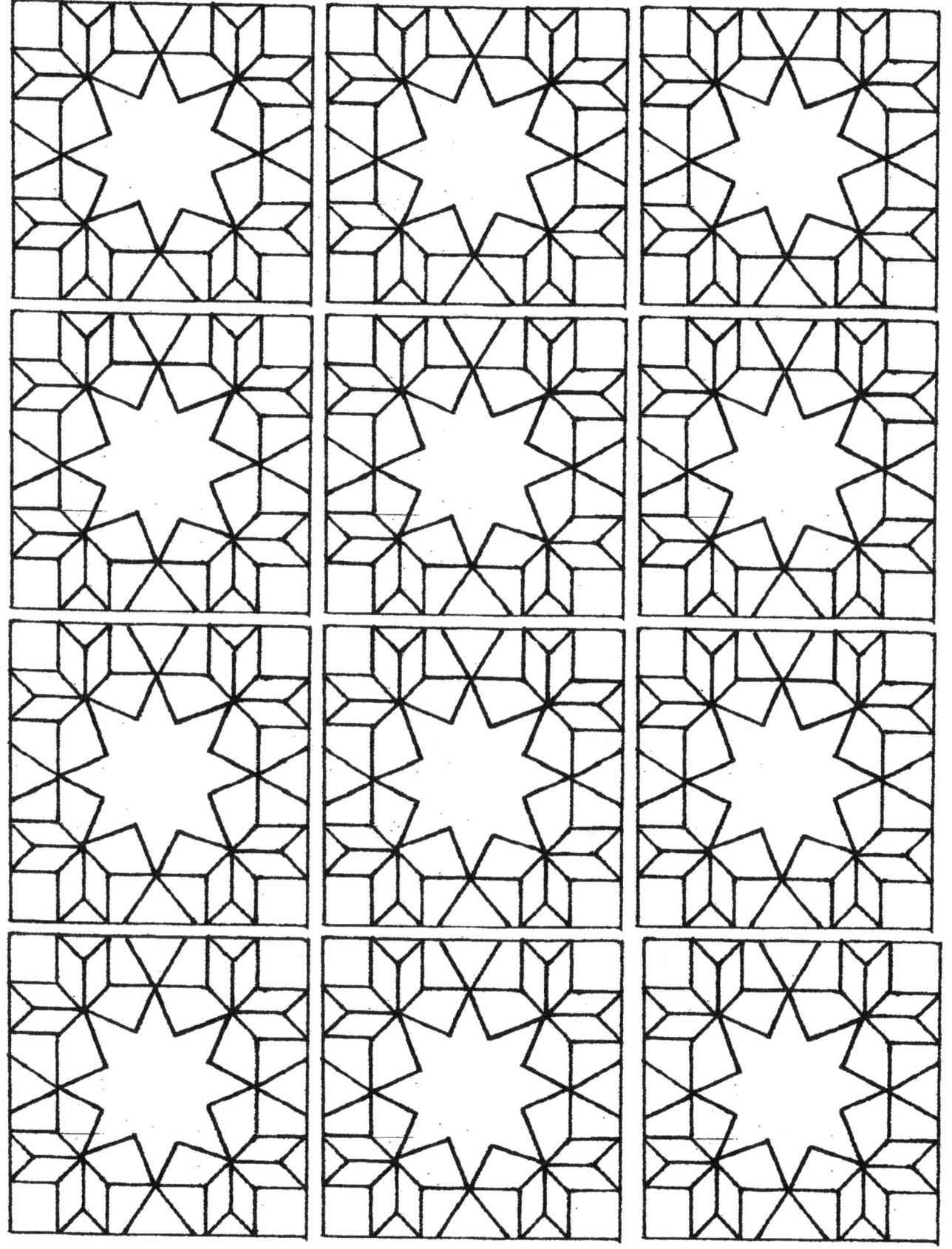

Barn Quilt All American
Shawano County Wisconsin Barn Quilts

Barn Located
East Main Street
Clintonville (Embarrass), Wisconsin

Wisconsin Barn Quilt All Americn Star

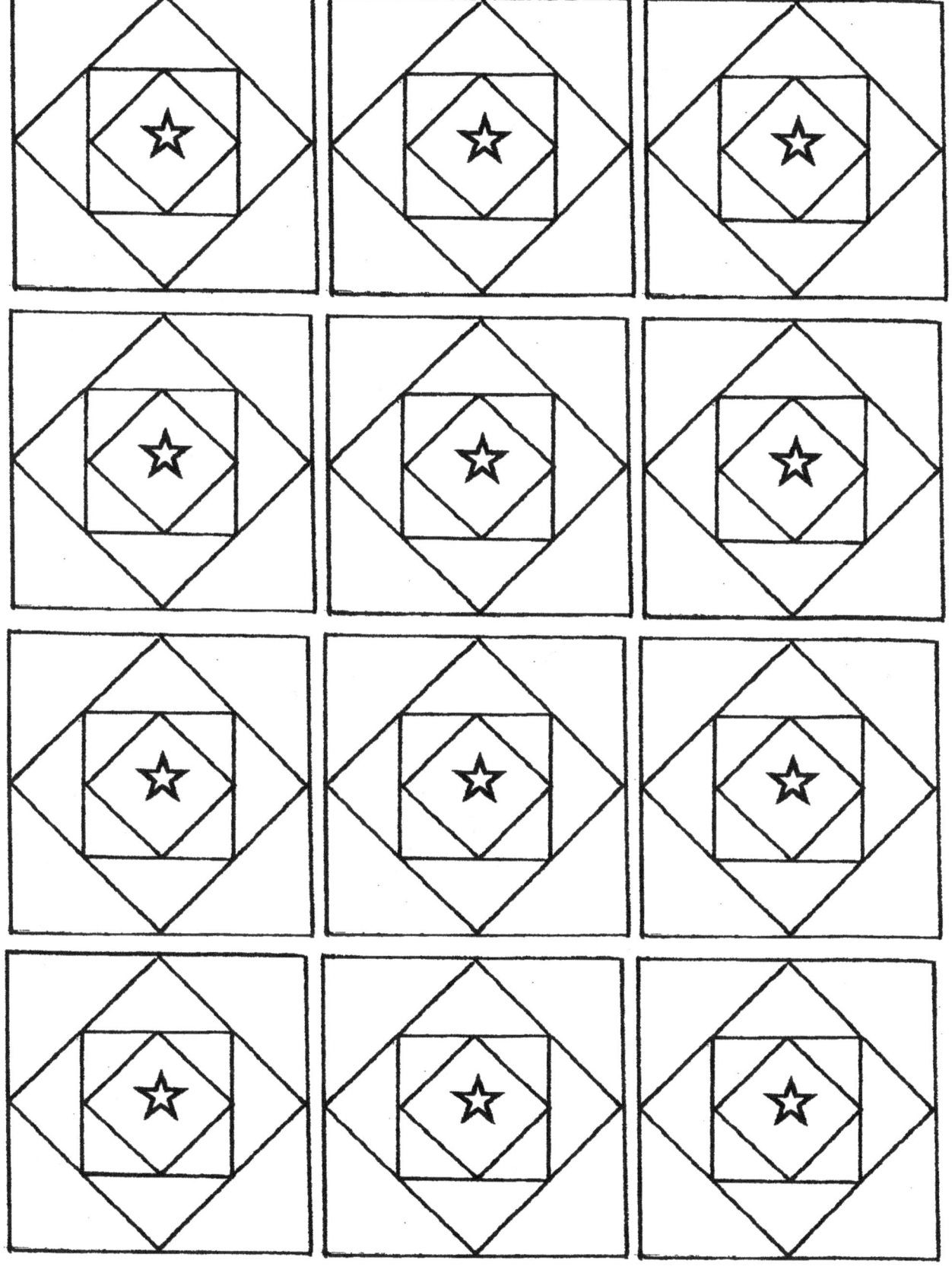

Barn Quilt Salute to Dairying
Shawano County Wisconsin Barn Quilts

Barn Located
Cedar Rd
Pulaski, Wisconsin

Wisconsin Barn Quilt Salute to Dairy

Barn Quilt Rueden Maple Leaf
Shawano County Wisconsin Barn Quilts

**Barn Located
State Hwy 156
Pulaski, Wisconsin**

Wisconsin Barn Quilt Rueden Maple Leaf

Barn Quilt Wintery Reflections
Shawano County Wisconsin Barn Quilts

Barn Located
Wilson Creek Lane
Wittenberg, Wisconsin

Wisconsin Barn Quilt Wintery Reflection

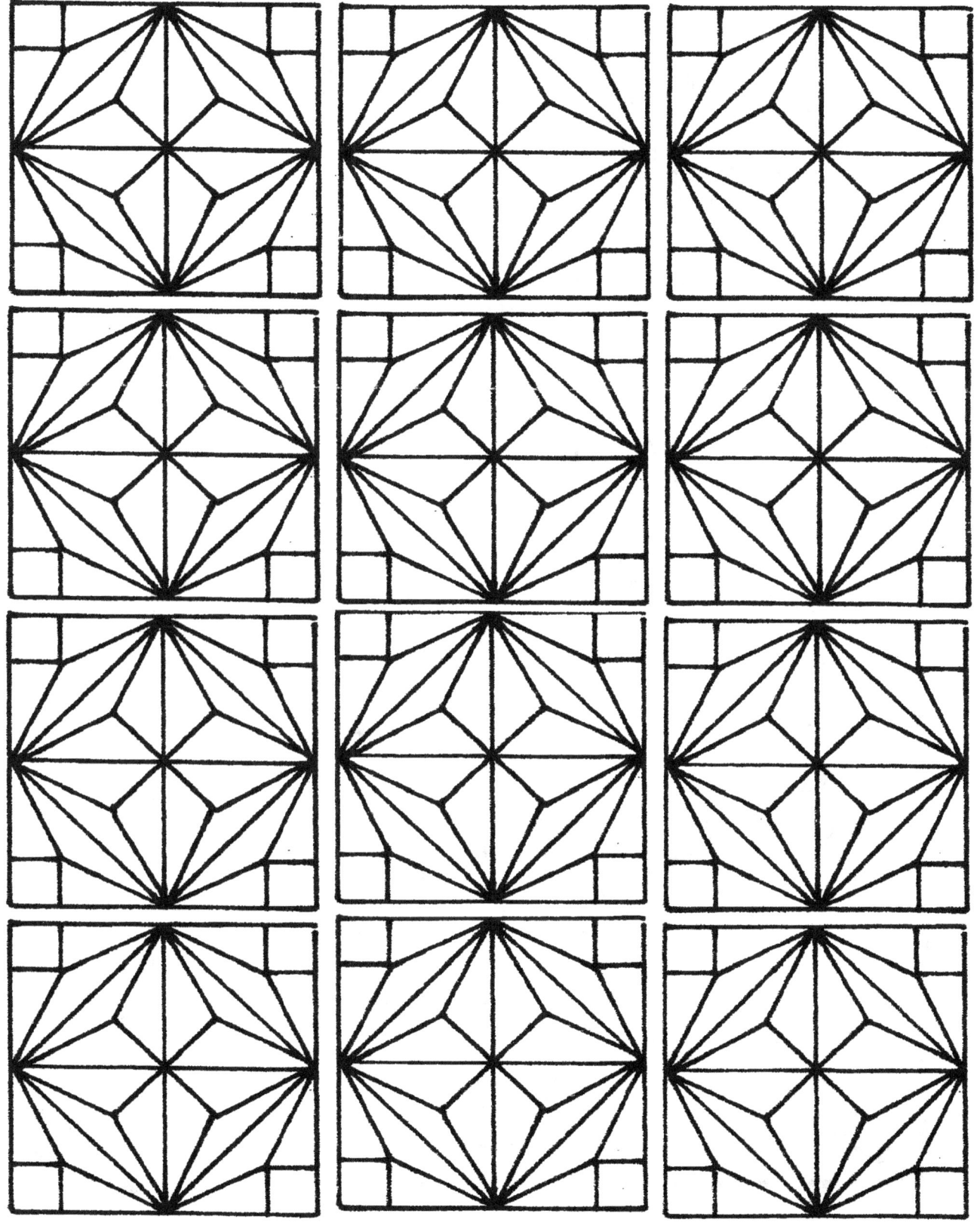

Barn Quilt Wayne's Dilemma
Shawano County Wisconsin Barn Quilts

Barn Located
State Hwy 22
Shawano, Wisconsin

Wisconsin Barn Quilt Wayne's Dilemma

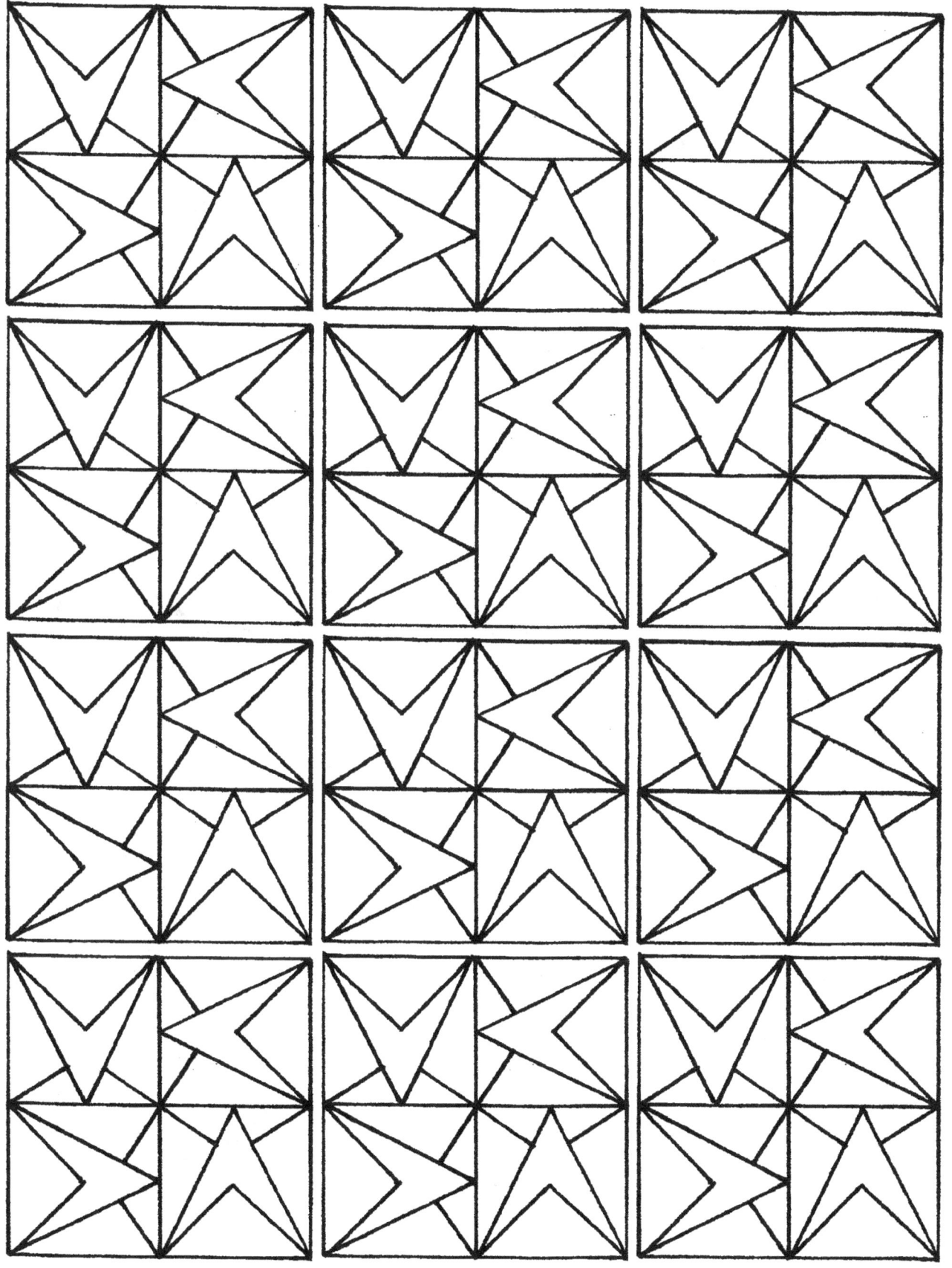

Barn Quilt Mother's Choice
Shawano County Wisconsin Barn Quilts

Barn Located
Tower Road
Tigerton, Wisconsin

Wisconsin Barn Quilt Mother's Choice

Barn Quilt Twirling Star
Shawano County Wisconsin Barn Quilts

**Barn Located
Sugarbush Road
Birnamwood, Wisconsin**

Wisconsin Barn Quilt Twirling Star

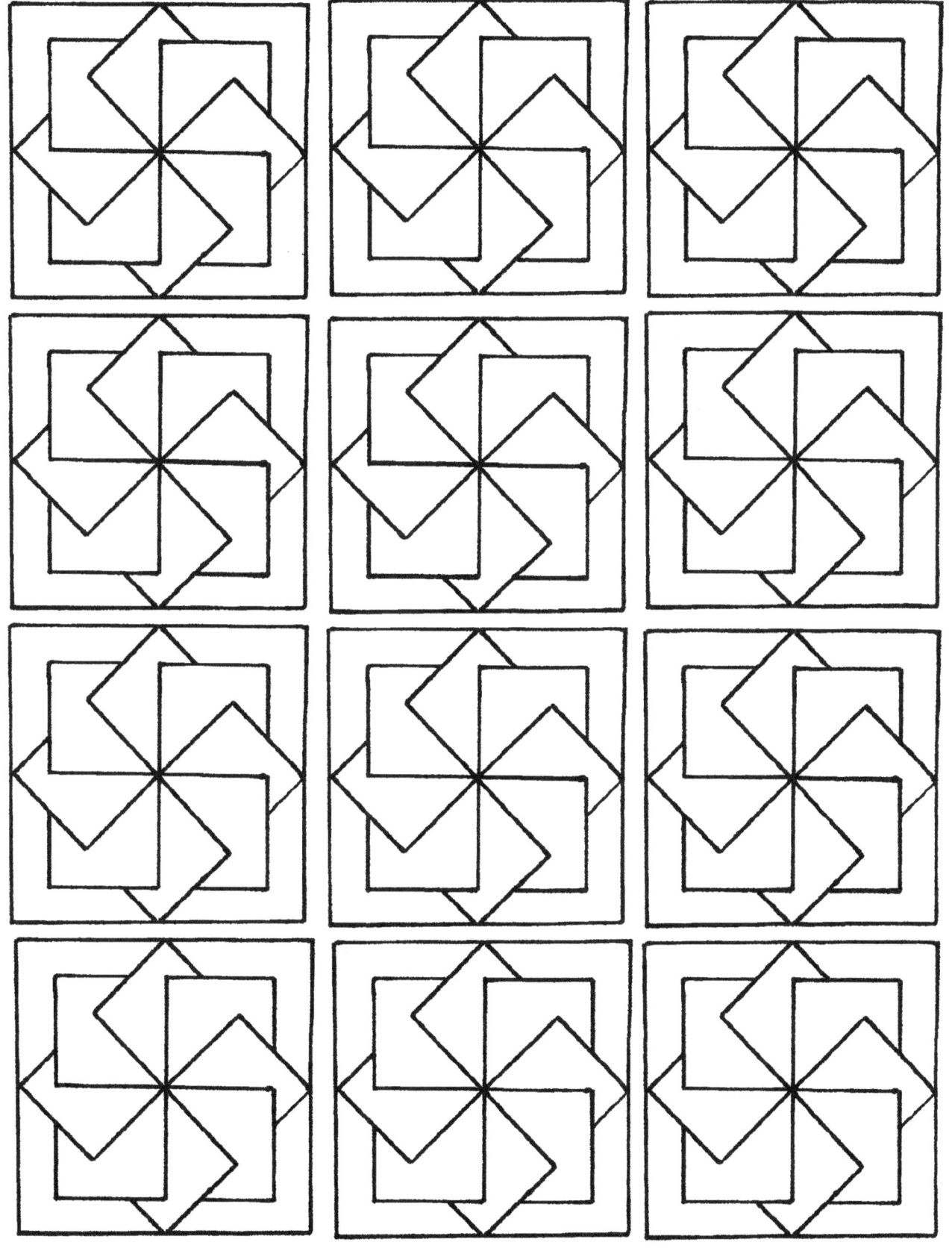

New Coloring Books by John H. Lettau

Additional Coloring Books by John H. Lettau

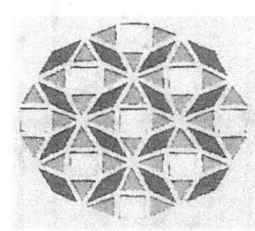

Geometric Design Coloring Book 1
Geometric Design Coloring Book 2
Geometric Design Coloring Book 3
Geometric Design Coloring Book 4
Geometric Design Coloring Book 5

Also create your own barn quilt patterns with...Graph Paper Designs

Coloring Books as Stress Therapy...Try it!!!

All John Lettau books are available at Amazon.com...google John H. Lettau

www.ingramcontent.com/pod-product-compliance
Lightning Source LLC
Chambersburg PA
CBHW081203180526
45170CB00006B/2195